IMAGES
of America

FLAGSTAFF

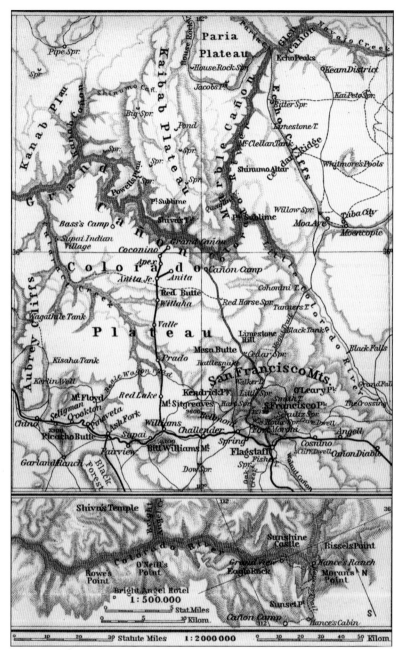

This steel-engraved map from 1903 shows Flagstaff in relation to the Grand Canyon, the San Francisco Peaks, and the Little Colorado River. It is noteworthy in showing the routes of the Beale wagon road, the Grand Canyon stage line, the Moqui trail to the Hopi villages, and the old trail to Supai. (Courtesy of the authors' collections.)

ON THE COVER: In this image, workers are pictured in the yard of the Arizona Lumber Company sawmill in the early 1880s. The mill was established in 1881–1882 by Chicago industrialist E. E. Ayer and was sold to Denis Matthew Riordan in 1887. The name was then changed to the Arizona Lumber and Timber Company. (Courtesy of Brian and Lois Chambers.)

IMAGES
of America

FLAGSTAFF

James E. Babbitt and John G. DeGraff III

ARCADIA
PUBLISHING

Published by Arcadia Publishing
Charleston, South Carolina

Printed in the United States of America

Library of Congress Control Number: 2009922896

For all general information contact Arcadia Publishing at:
Telephone 843-853-2070
Fax 843-853-0044
E-mail sales@arcadiapublishing.com
For customer service and orders:
Toll-Free 1-888-313-2665

Visit us on the Internet at www.arcadiapublishing.com

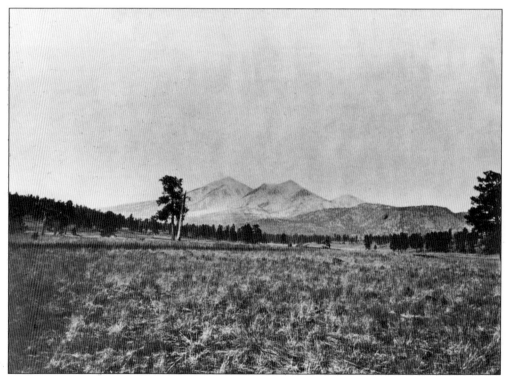

Pictured here is Mount Agassiz, Arizona. Alexander Gardner, the official photographer for the Kansas Pacific Railway survey, took this image in December 1867. The view is looking north toward the San Francisco Peaks from Antelope Spring, near today's Flagstaff Middle School. It is probably the first photograph ever taken in the Flagstaff area. (Courtesy of the authors' collections.)

CONTENTS

ACKNOWLEDGMENTS

Assembling the images for this volume was a considerable challenge and a task that could not have been completed successfully without the cooperation and assistance of many institutions and individuals. The authors drew from the photographic collections of academic, historical, and scientific repositories, as well as from their own collections and those of other Flagstaff families. Professional librarians and archivists, as well as descendants of the pioneer Riordan, Babbitt, Pollock, Michelbach, Greenlaw, Herman, Bader, and Verkamp families, provided a wealth of interesting and, sometimes, rare images that reveal Flagstaff's rich and diverse history. In particular, the authors would like to acknowledge the following: the Arizona Historical Society, Southern Division—Katherine Reeve, head of library and archives, and Robert Orser, photographer; the Arizona Historical Society Pioneer Museum—Les Roe, director; Joe Meehan, curator; and Vincent Richie, museum assistant; the Lowell Observatory—Antoinette Beiser, librarian; Kevin Schindler, outreach manager; and Ben Crandell, educator; the Museum of Northern Arizona—Jonathan Pringle, archivist; Ed Evans, librarian; and Libby Coyner, intern archivist; the Northern Arizona University Cline Library, Special Collections and Archives—Karen J. Underhill, coordinator, and Jess Vogelsang, digital access library specialist, senior; and the U.S. Forest Service, Coconino National Forest—Karen Malis-Clark, deputy public affairs officer, and Steve Harper, visitor services specialist; Jack and Billie Faye Beamer; Brian and Lois Chambers; Marilyn Michelbach Coy; Maury Herman; and Ann, Kay, Tom E. Pollock III, and Claudine Randazzo. The authors also owe a special debt of gratitude to Luana Buzzell, office manager for Babbitt Ranches, who spent countless hours scanning images and organizing text. Thank you all for helping to keep Flagstaff's history alive for future generations.

All images are from the collections of the authors unless otherwise noted.

INTRODUCTION

A travel article published in the February 27, 1892, edition of Chicago's the *Graphic*, an illustrated magazine, described Flagstaff and the surrounding country as "one of the most interesting regions between the Missouri River and the Pacific." The writer went on to note that Flagstaff offered majestic scenery and natural resources such as timber and grazing lands, as well as geologic features and native cultures of great scientific interest. The reporter predicted that Flagstaff would become a truly great summer resort and a world-famous gateway to some of the greatest natural marvels and most interesting native cultures "to be found in any portion of the globe." This book traces the story of how these predictions were born out as Flagstaff was settled, industries and tourism were developed, scientific and educational institutions were established, and a tiny railroad community grew to be the "Mountain Town" we know today.

At an elevation of some 7,000 feet, Flagstaff is surrounded by an area of intense volcanic activity known as the San Franciscan Volcanic Field. Ancient seas and vast deserts once covered this landscape, and they deposited layer upon layer of sedimentary rocks. Uplifting, faulting, and erosion sculpted these strata into jagged mesas, immense cliffs, and deep canyons. In more recent geologic time, magma erupted from deep below the Earth's surface, building lava flows, cinder cones, and large volcanoes like Sunset Crater as well as the towering volcano of the San Francisco Peaks.

Thousands of years ago, peoples of the Archaic Period inhabited this landscape. Evidence of this early culture includes delicately shaped arrowheads and beautifully executed rock art images. Other Native American cultures followed, including the Ancestral Puebloans, who built impressive cliff dwellings, and the Hopi, who established pueblos on the high mesas to the northeast of Flagstaff. Hallmarks of these cultures include fine ceramics, basketry, and interesting rock art. Later still, the lands surrounding Flagstaff became home to several other tribes, including the Apache, Hualapai, Havasupai, Navajo, and Paiute peoples. These native cultures continue to thrive, and their rich traditions play a vital role in the life of Flagstaff and northern Arizona.

The first nonnative people to travel across northern Arizona were Spanish explorers and missionaries. In 1540, the Coronado expedition, searching for the fabled golden cities of Cibola, visited the Hopi mesas. A detachment of soldiers under the command of Pedro de Tovar was the first group of Europeans to view the Grand Canyon, probably from a point on the south rim near present-day Desert View. By 1629, the Spanish were establishing missions among the Pueblo tribes of the Southwest. In 1680, the friars were expelled during the Pueblo Revolt but later returned to resume their work of conversion and conquest.

In the decades preceding the Civil War, America was expanding across the western frontier in fulfillment of the country's Manifest Destiny. Congress became interested in the construction of a transcontinental railroad to the Pacific Ocean. It was hoped that the proposed railway would facilitate trade with Asia and would stimulate settlement and development of the frontier west. In 1853, Congress authorized surveys of several transcontinental railroad routes, including one

along the 35th parallel across northern Arizona. That survey, under the direction of Lt. Amiel Weeks Whipple, along with another in 1867 led by Gen. William Jackson Palmer, demonstrated the feasibility of the 35th parallel route to the Pacific. In 1857, this same route was followed by Lt. Edward Fitzgerald Beale, who constructed a wagon road along the 35th parallel from Albuquerque to Southern California. The Beale road brought early settlers into the Flagstaff area, including Thomas F. McMillan, probably the area's first permanent resident. A native of Tennessee, McMillan brought sheep to the Flagstaff area in 1876 and established a homestead just north of Flagstaff's present-day downtown.

On July 4, 1876, a party of emigrants from Boston traveling the Beale road to California was camped at Antelope Spring near the McMillan homestead. To celebrate the nation's centennial, the pioneers stripped the limbs from a tall ponderosa pine tree and raised the Stars and Stripes on the makeshift flagstaff. The name persisted, and the area's first post office—called Flagstaff—was established in 1881.

In the spring of 1882, the Atlantic and Pacific Railway was being constructed across northern Arizona. The area's vast ponderosa pine forest provided a limitless supply of wood for cross ties for the rails. A Chicago industrialist and supplier of railroad construction materials, Edward E. Ayer, established a sawmill at the base of Observatory Mesa (Mars Hill). On a slope at nearby Old Town Spring, tents were erected for the railroad workers, and structures of milled pine lumber were built to house saloons, stores, a news depot, and a rooming house. The first train arrived at Old Town on August 1, 1882.

Besides timber, the railroad crews required quarried stone for use in bridge footings, headwalls, and tunnels. A large outcropping of Moenkopi sandstone at the edge of a mesa east of Old Town provided stone that was easily cut, but it hardened upon exposure to the air. A quarry was opened to supply the railroad and later became an important source of stone for public buildings as far away as Los Angeles, Denver, and San Francisco. By 1884, Flagstaff's commercial area was moving east to a more level area known as New Town. The fire-resistant "Flagstaff red" sandstone was used in the construction of several of the new commercial structures, and the quarry continued to be an important part of Flagstaff's economy for many years.

The coming of the railroad, and later the automobile, gave rise to another important facet of Flagstaff's economic history—tourism. The Atlantic and Pacific Railway, renamed the Atchison, Topeka, and Santa Fe, promoted travel to sights such as the Grand Canyon, the Painted Desert, and the Petrified Forest, as well as to points of interest on the Navajo and Hopi reservations. The Fred Harvey Company established renowned hotels and eating houses along the railroad to accommodate tourists and to promote the arts and crafts of the native peoples and their ceremonials. Later roads were improved, and automobile tourism flourished along the National Old Trails highway system and along the now-famous U.S. Route 66. During the Great Depression of the 1930s, thousands fleeing the dust bowl of Oklahoma streamed across northern Arizona to California. Small auto courts and roadside diners sprang up to serve the flow of travelers, giving Flagstaff's main thoroughfare a unique Route 66 flavor that endures to this day.

Endowed with abundant scenic beauty, natural and cultural resources, and situated on the Southwest's major east-west transportation route, Flagstaff is a city with a rich and diverse history. The tiny outpost beside the railroad tracks has certainly fulfilled the hopes of that early Chicago travel magazine writer who "commended Flagstaff to all who desire a rewarding glimpse of our ever-widening resources, and as a most promising point for the settler, the capitalist, the tourist, the scientist and the artist."

One

PEAKS, CANYONS, AND CRATERS

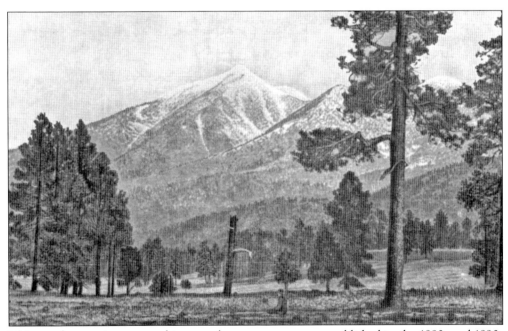

This wood engraving was used in several government reports published in the 1880s and 1890s on the biology, geology, and ethnology of northern Arizona. This view shows Agassiz Peak and a glade with old-growth ponderosa pine in the era before logging.

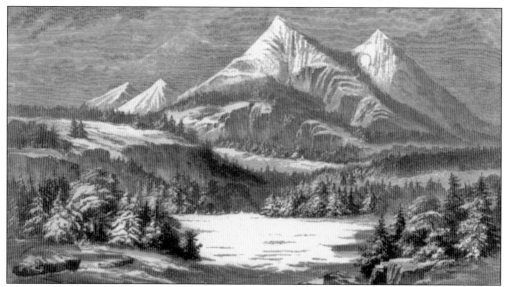

This woodcut shows the San Francisco Peaks and the camp of the 1853 Whipple railroad survey expedition from a point in Fort Valley near Leroux Spring. The image is based on an original sketch by Baldwin Mollhausen, the official artist of the Whipple survey.

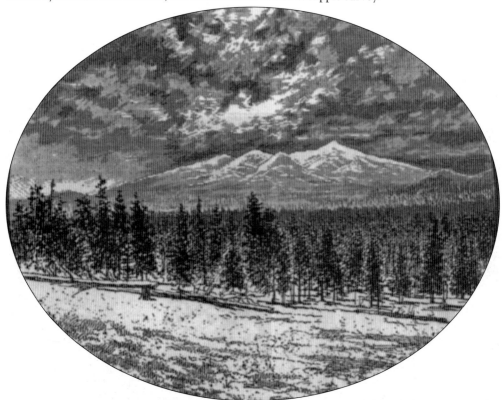

This early woodcut shows a view of the San Francisco Peaks from the north at a point on the Grand Canyon stagecoach road. The image illustrated a travel article on Flagstaff published in Chicago's the *Graphic* illustrated magazine in 1892.

A beautiful watercolor by famed Grand Canyon artist Thomas Moran shows the San Francisco Peaks and the Dry Lake Hills from a point in the valley near today's Lockett Estates. This image illustrated an 1893 Santa Fe Railway promotional publication on the Grand Canyon and the Colorado River.

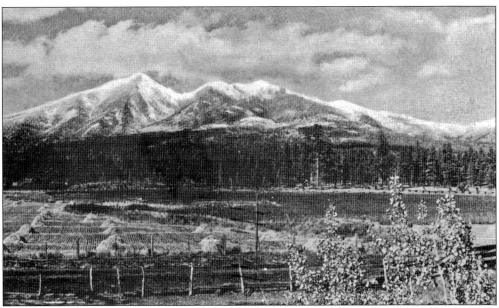

In the early 1600s, a group of Franciscan missionaries at Oraibi named the San Francisco Peaks in honor of Saint Francis of Assisi, the founder of their order. This view shows a hay farm at the foot of the peaks at Fort Valley.

The San Francisco Peaks can be seen from a considerable distance in every direction. This view is from Fort Whipple near Prescott. The highest peak, Mount Humphreys, was named for railroad surveyor Andrew Atkinson Humphreys. The second highest, Agassiz Peak, was named for Jean Louis Rodolphe Agassiz, a Swiss naturalist and Harvard professor.

This view of the interior valley, or inner basin, of the San Francisco Peaks volcano looks south toward Doyle Peak. The subalpine forest of the basin is composed of Englemann spruce, bristle-cone pine, and Arizona fir. As shown in the image, forest fires regularly burned across large areas of the peaks.

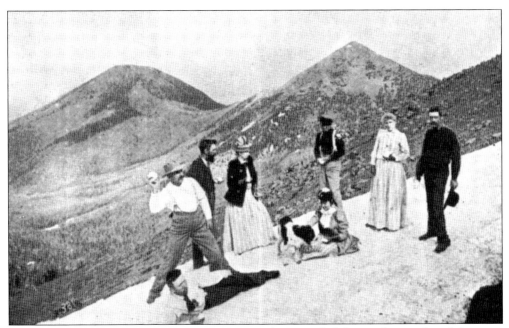

During the last ice age, some 10,000 years ago, a glacier eroded the northeast edge of the inner basin. In more recent times, snow sometimes remained on the higher slopes of the peaks well into the summer, providing some cool recreation for these early-day Flagstaff residents.

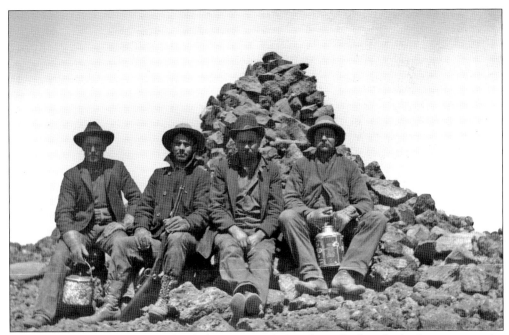

Rising to 12,633 feet above sea level, the summit of Humphreys Peak is the highest point in the state of Arizona. Here a tank construction crew from the nearby C. O. Bar Ranch enjoys the splendid view from the summit after conquering the peaks on April 17, 1904.

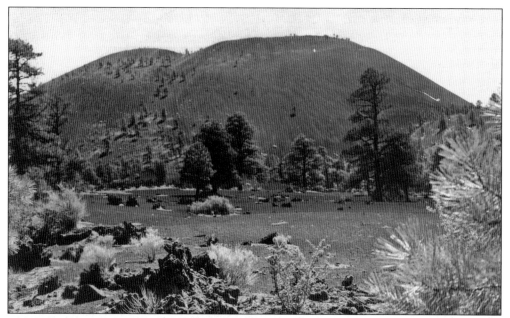

Sunset Crater is a large cinder cone northeast of Flagstaff. It is the youngest cone in the San Franciscan Volcanic Field. It erupted between 1040 and 1100 AD. The crater was named by John Wesley Powell, who likened the red and orange cinders around the crater's rim to the colors of a sunset.

As the lava flows around Sunset Crater cooled, pockets of air formed cool subterranean chambers, or ice caves. Pres. Herbert Hoover created the Sunset Crater Volcano National Monument in 1930.

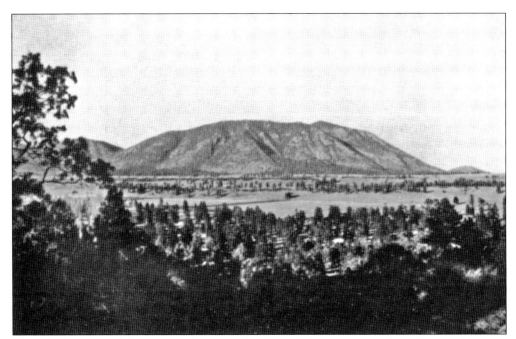

Mount Elden, named for pioneer sheep rancher John Elden, is a dome-shaped mass of igneous rock that rises to an elevation of 9,280 feet above sea level. On the mountain's east and north sides, sedimentary strata are exposed where they were uplifted by laccolithic intrusion.

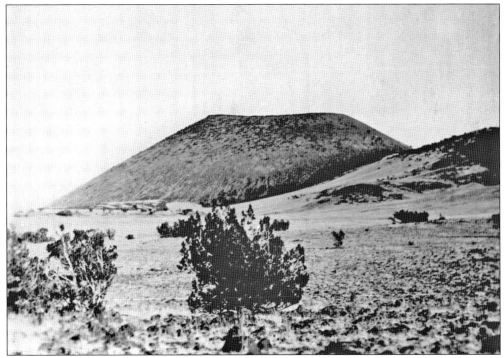

The S. P. Crater, named by C. J. Babbitt for its resemblance to a chamber pot, resulted from an eruption in the later stages of volcanic activity in the area north of the San Francisco Peaks. A large lava flow issued from the north side of the S. P. Crater.

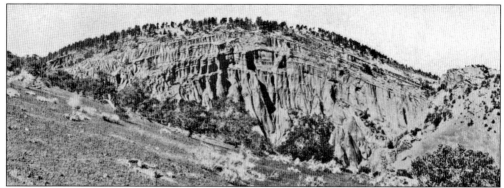

Red Mountain is a highly eroded ash cone north of Kendrick Mountain. It has been the subject of intensive geologic study because it reveals the internal structure of volcanic cinder cones. A hiking trail now leads to beautiful scenery inside the crater.

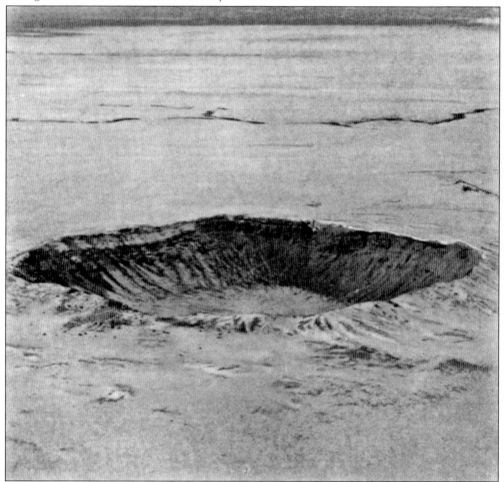

More than 50,000 years ago, a meteor crashed into the Earth some 40 miles east of Flagstaff. Originally called Coon Mountain, the crater was renamed Meteor Mountain, or Meteor Crater, when Daniel Moreau Barringer correctly recognized that the crater was formed by the impact of a meteorite.

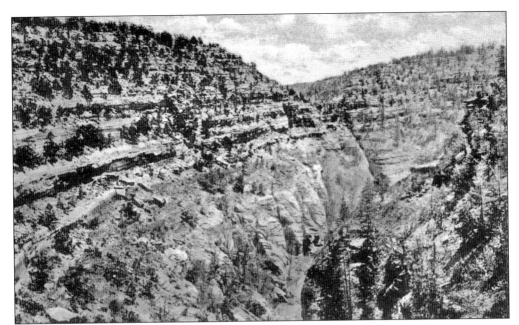

Walnut Canyon is named for the Arizona black walnut tree that grows in the area. This deep canyon was carved in the Kaibab limestone and Coconino sandstone by faulting and by the waters of Walnut Creek. South-facing canyon walls tend to be drier, warmer, and more desert-like, while the north-facing walls are shady, cool, and moist.

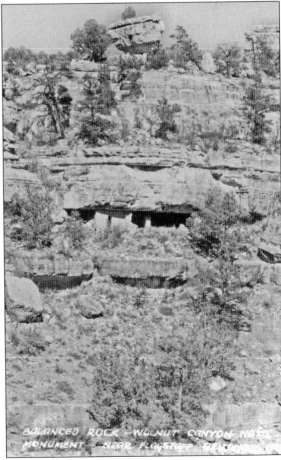

Rock overhangs along the walls of Walnut Canyon were used as shelters by the prehistoric Sinauga culture. By 1900, looting of the ruins and pothunting were becoming serious problems. Flagstaff Catholic priest Cypriano Vabre and other local residents organized against these practices and lobbied for the protection of the ruins. Pres. Woodrow Wilson created the Walnut Canyon National Monument in 1915.

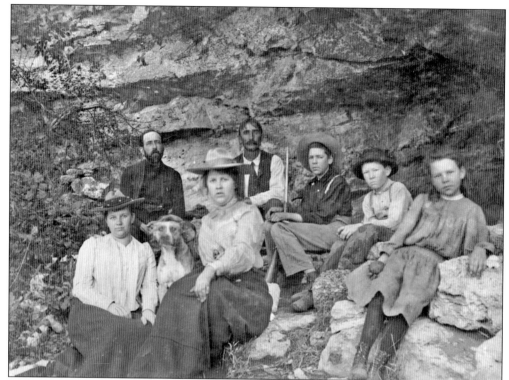

Walnut Canyon was a popular destination for early-day sightseers and picnickers. In this view, Flagstaff resident George Hochderffer (second row, right) joins the George Babbitt family for a weekend outing in 1902. The Babbitt children, (from left to right) Bertrand, Herbert, and Margaret, are shown on the right. (Courtesy of Arizona Historical Society/Tucson AHS PC.64F2-4846.)

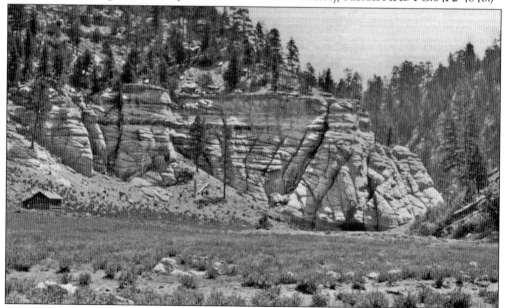

Fisher Point is a large outcropping of cross-bedded sandstone near the beginning of the Walnut Creek drainage. The point, with a deep cave at its base, was a familiar landmark to early residents.

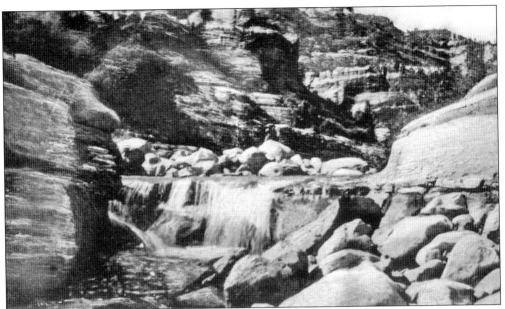

Oak Creek Canyon, south of Flagstaff, has been a popular area for swimming, fishing, and bird-watching for decades. Every summer, visitors flock to the creek to enjoy its cool, clear waters.

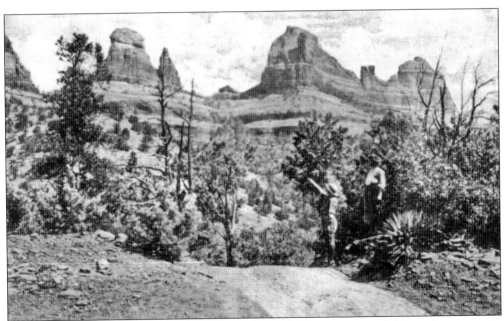

The road from Flagstaff to Sedona through Oak Creek Canyon is one of Arizona's most scenic routes. Lush vegetation along the creek and spectacular red-rock formations are delightful vistas for the tourist.

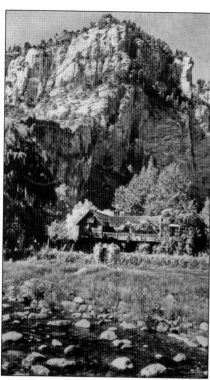

Mayhew's Lodge, near the mouth of Oak Creek's west fork, offered rooms and meals in a spectacular setting. Closed in the 1970s, the rustic building later burned. Nearby is today's West Fork trailhead.

Pictured below is the second bridge across Oak Creek at Slide Rock. The first bridge burned in 1917 but was rebuilt the following year. Vera Greenlaw, of the pioneer lumbering family, took this photograph. Today's Slide Rock State Park attracts thousands of visitors annually. (Courtesy of Jack and Billie Faye Beamer.)

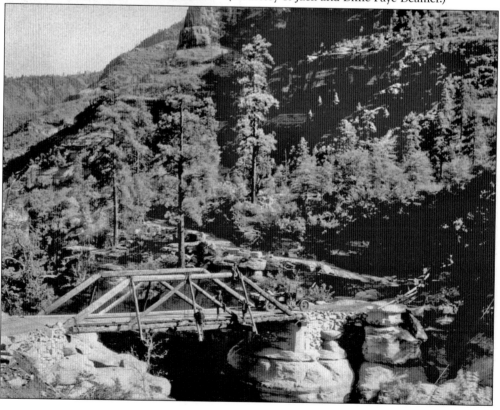

From its beginning, Flagstaff has been a gateway to the Grand Canyon, some 90 miles to the north. Tourists from the world over have come to see one of the world's natural wonders. Grand Canyon National Park was established in 1919. Today the Grand Canyon attracts more than five million visitors annually.

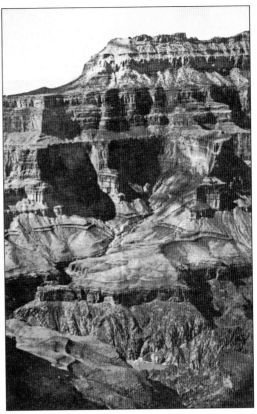

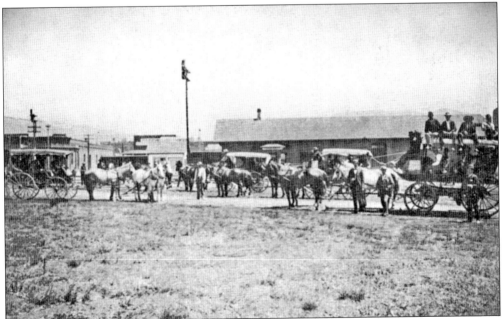

A stagecoach line from Flagstaff to the Grand Canyon was established in 1892. This view shows tourists at the railway depot about to depart on their journey to the canyon's South Rim in 1897. At that time, the proprietor of the stage line was J. W. Thurber.

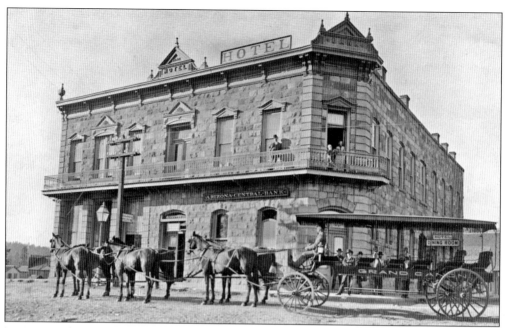

At the northwest corner of Leroux Street and Railroad Avenue, the Bank Hotel was built in 1886 by Thomas F. McMillan. As shown in this view, the building housed the Arizona Central Bank and a hotel, which was a popular accommodation for travelers on their way to and from the Grand Canyon. (Courtesy of Arizona Historical Society/Tucson AHS 53700.)

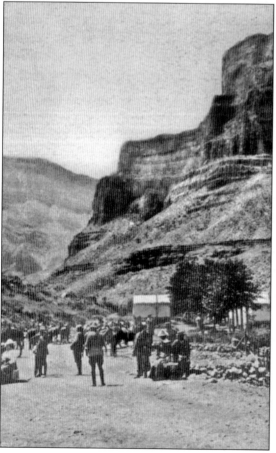

The Indian Garden is about a two-hour hike below the Grand Canyon's South Rim. It is one of the few sources of water on the south side of the canyon and offers today's hikers and campers a cool, green oasis. As its names implies, Indian Garden was also used by prehistoric peoples.

Two

NATIVE PEOPLES

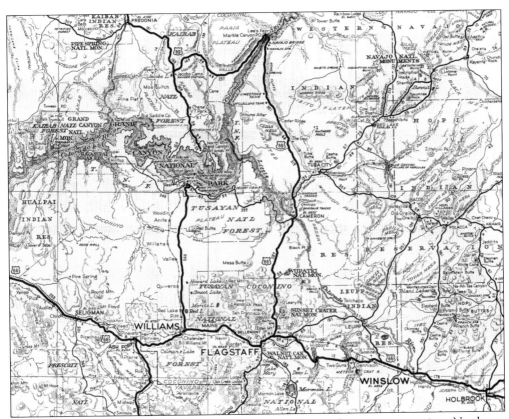

This map shows Flagstaff in relation to northern Arizona's Native American reservations. Northwest of Flagstaff are the Hualapai and Havasupai reservations. North of the Grand Canyon is the Kaibab Paiute reservation. To the east and northeast of Flagstaff are the Hopi and Navajo reservations.

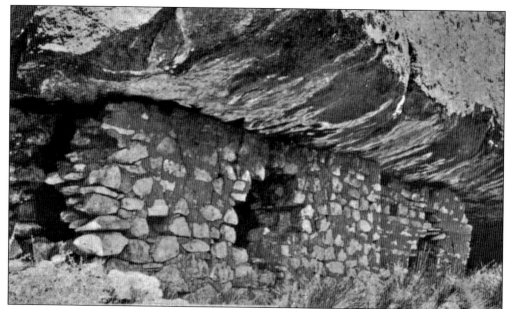

Some of the Flagstaff area's first inhabitants were the Sinagua, a prehistoric culture that occupied Walnut Canyon from about 600 to 1400 AD. The Sinagua built cliff dwellings under overhangs along the canyon walls. Some archaeological evidence suggests a link between the Sinagua peoples and the Hopi.

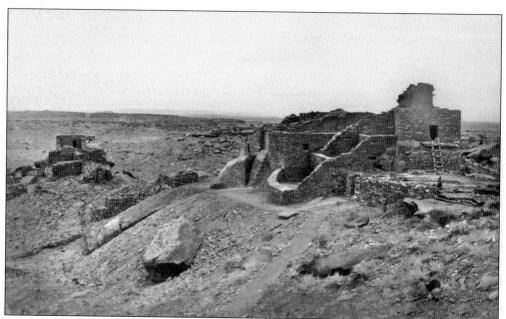

Pres. Calvin Coolidge created the Wupatki National Monument about 40 miles north of Flagstaff in 1924. Pres. Franklin Roosevelt expanded the monument in 1937. Wupatki was occupied by the Kayenta Ancestral Puebloans, the Sinagua, and the Cohonina. The area was inhabited for a fairly brief period, probably from about 1100 to 1250 AD.

Pres. Theodore Roosevelt established the Montezuma Castle National Monument about 50 miles south of Flagstaff in 1906. When early explorers first saw the multistory cliff dwelling, it was mistakenly believed to be a ruin built by the Aztecs of Mexico. The five-story, 20-room structure was occupied by the Sinagua culture from the 12th to the 14th centuries.

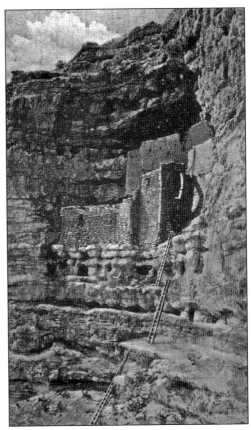

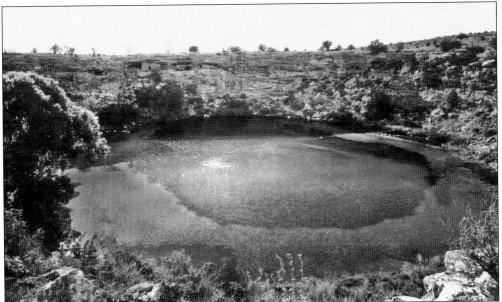

The Montezuma Well, a detached unit of the Montezuma Castle National Monument, is a flooded limestone sinkhole some 55 feet deep. The Sinagua used the well's water to irrigate crops in nearby fields.

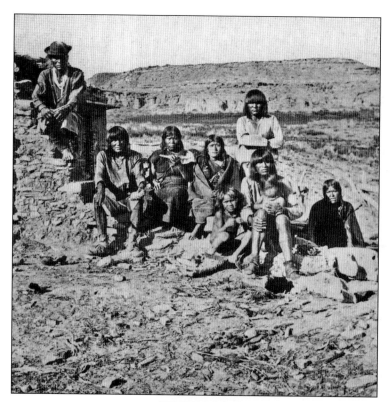

This view shows Hopi leader Tuvi (standing) near the village of Moenkopi; modern-day Tuba City is named for him. The photograph was taken in 1872 by Elias Orcutt Beaman, formerly the official photographer for the second Powell expedition down the Colorado River in 1871–1872.

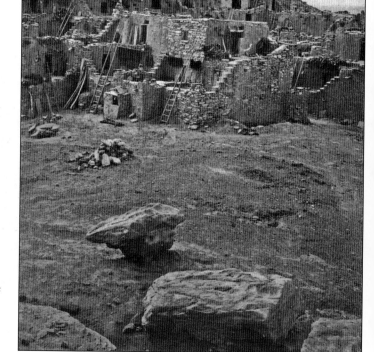

Another photograph by Beaman shows the Hopi village of Mishongnovi. Beaman left the Powell expedition in the winter of 1871 and traveled to the Hopi mesas, where he made an extensive series of views documenting Hopi villages and their inhabitants.

26

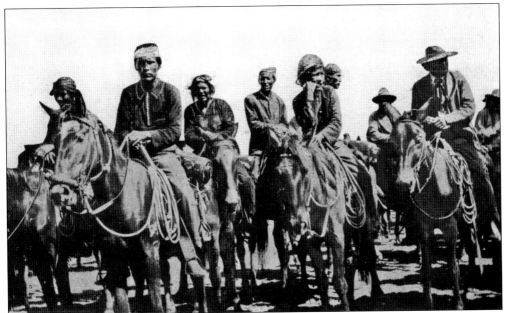

The Navajo are an Anthabascan-speaking tribe that settled in the southwest hundreds of years ago. Traditional Navajos believe that their homeland is encompassed by four sacred mountains: Blanca Peak and Hesperus Peak in Colorado, Mount Taylor in New Mexico, and the San Francisco Peaks.

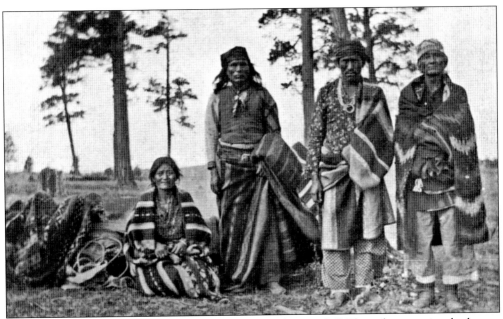

The Navajo call themselves "Dineh," which means "the people." The tribe occupies the largest reservation in the United States, which sprawls across northeast Arizona, northwest New Mexico, and southern Utah.

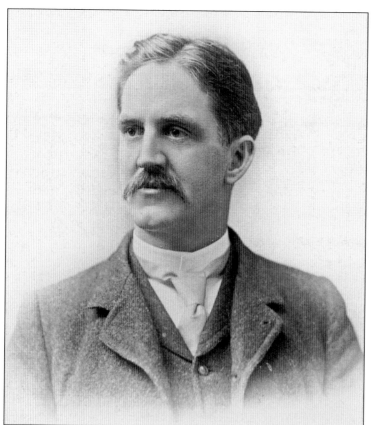

In the early 1880s, Denis Matthew Riordan was the agent for the U.S. Indian Service at Fort Defiance on the Navajo reservation. He left his position as Indian agent in 1884 and relocated to Flagstaff to manage E. E. Ayer's large lumber mill. In 1887, Riordan purchased the mill from Ayer. (Courtesy of Brian and Lois Chambers.)

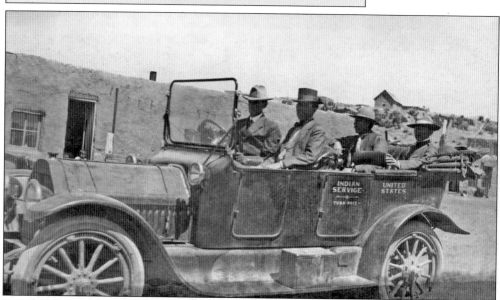

Pictured about 1915 is Walter Runke (at far right), the U.S. Indian Service agent at Tuba City on the western Navajo reservation. Runke later served as postmaster in Flagstaff and was active in civic affairs. His wife, the former Laura Preston, served on the Flagstaff City Council from 1966 to 1970. (Courtesy of NAU Cline Library Leo Crane Collection.)

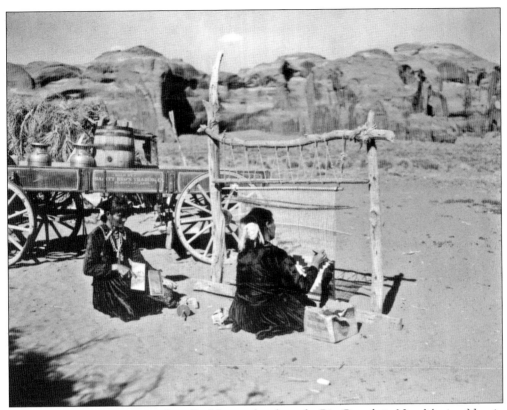

The Navajos learned to weave from Pueblo peoples along the Rio Grande in New Mexico. Navajo rugs are known and prized the world over for their beautiful designs and fine execution. In the Navajo culture, women are the primary weavers.

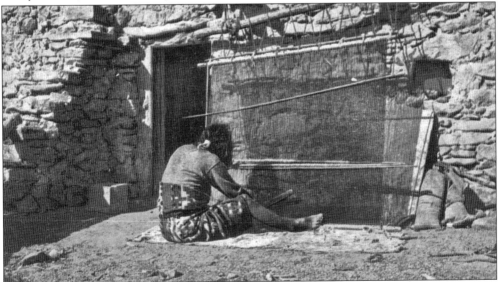

This Hopi weaver at Oraibi was photographed around 1909. Hopi men weave sashes, kilts, and mantas, which are used primarily for ceremonial purposes. The Hopi are also known for their beautiful pottery, wicker plaques, and overlay silver jewelry.

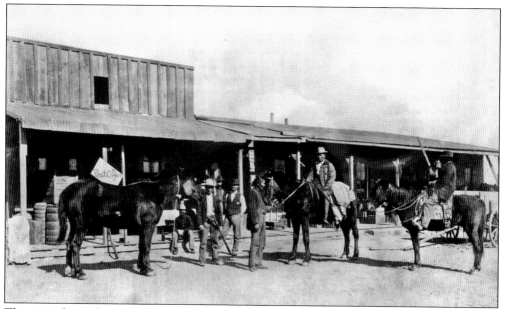

This view shows the trading post at Canyon Diablo about 1903. The store was established next to the Atlantic and Pacific Railway tracks about 35 miles east of Flagstaff in the early 1880s by Charles Algert and was later operated by Frederick Volz. Volz (in vest) is shown here with a posse led by C. O. Bar Ranch foreman Eli Lucero (standing with rifle).

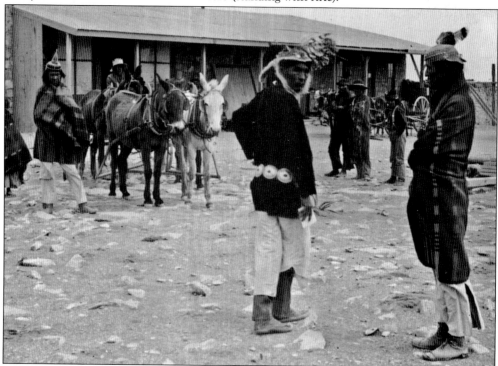

Another view of the Canyon Diablo trading post is shown from 1905. Gathered in front of the store is a group of Navajo men in ceremonial headgear and wrapped in Pendleton blankets. The photograph was taken early in the morning following a nighttime ceremony.

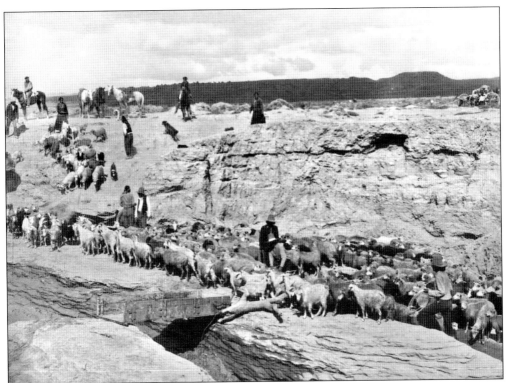

The Navajo obtained sheep from early Spanish settlers in the southwest. Flocks are a common sight all across the vast Navajo reservation. Mutton stew is a favorite Navajo dish, and wool is used for weaving Navajo rugs. Traditional Navajos measured their wealth according to the number of sheep they possessed.

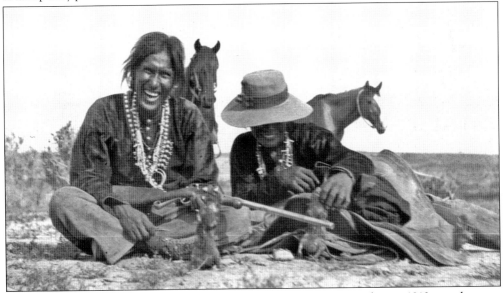

These two Navajos were guides for former president Theodore Roosevelt on a 1913 expedition to the Grand Canyon, Rainbow Bridge, and the Hopi mesas. The guides posed with several prairie dogs, which were shot and roasted for dinner.

In the 1890s, small trading stores were established across the vast Native American country northeast of Flagstaff. Rugs, baskets, and jewelry were bartered for food and supplies. The Native American arts and crafts were, in turn, for mail order by merchants in towns bordering the reservation.

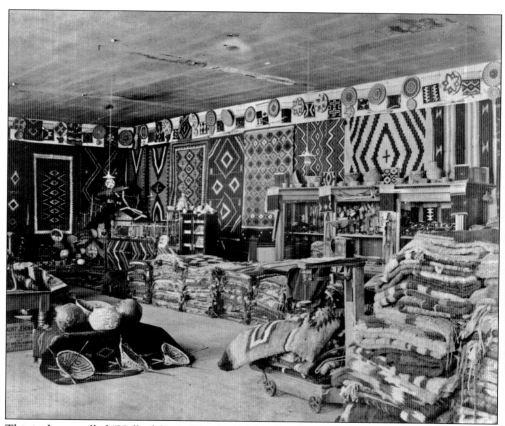

This is the so-called "Hall of Curios" in the Babbitt Brothers store in downtown Flagstaff. Piles of rugs, burden baskets, pitch pots, wicker plaques, katsina dolls, silver jewelry, and pottery are seen offered for sale in this 1898 photograph.

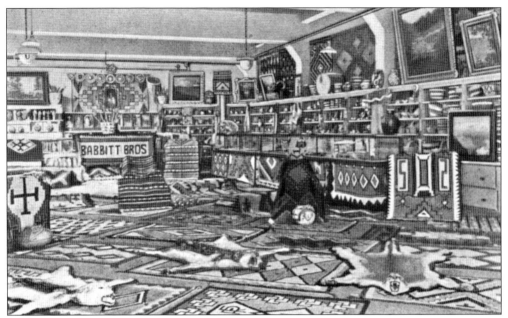

This view shows the curio room in the Babbitt Brothers store in the 1920s. Merchandise offered for sale had expanded to include moccasins, beadwork, animal pelts, and paintings by artists such as Louis Akin, Thomas Moran, and Jimmy Swinnerton.

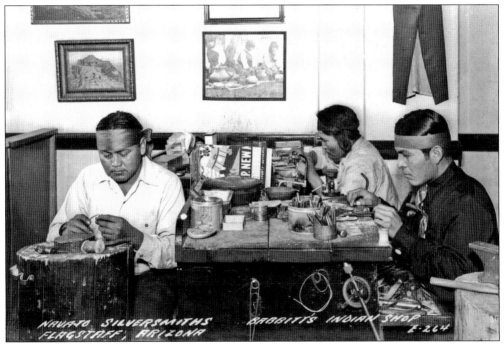

Some firms employed Navajo weavers and silversmiths to demonstrate their crafts on premises. This photograph shows three Navajo silversmiths working on stamped silver bracelets and pendants at the Babbitt Brothers store in the 1930s.

Other well-known Flagstaff retailers of Native American arts and crafts were Percy J. McGough, owner of the Nava-Hopi Trading Company, and John W. Francis, manager of the Flagstaff Commercial Company. The Native American handcraft trade is still an important retail business in downtown Flagstaff.

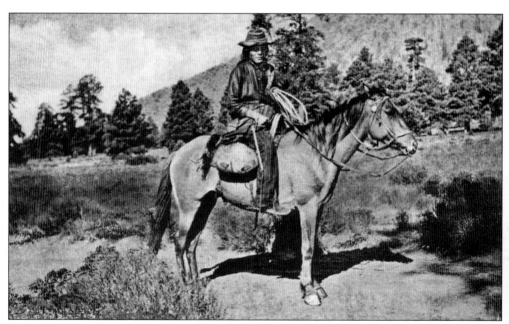

The U.S. Post Office employed Native Americans to carry mail to roadless and inaccessible areas of the reservations. Pictured here is a mounted mailman on his way to the remote village of Supai.

Three

THE RAILROAD

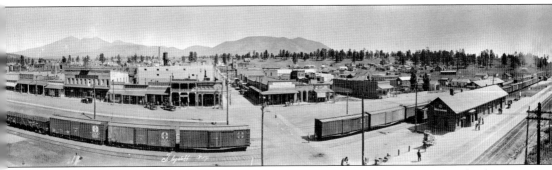

A 1912 panorama from the top of the new Santa Fe water tower shows passengers at the depot and boxcars along the tracks ready to unload freight. (Courtesy of AHS-Pioneer Museum.)

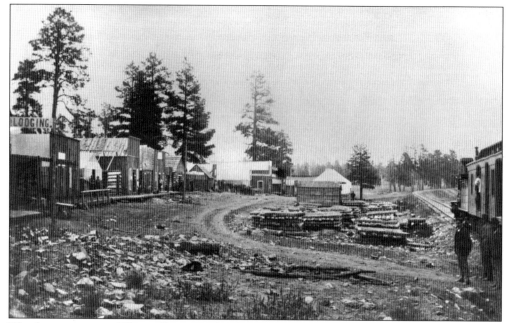

The first town site of Flagstaff was on the slope of Mars Hill near Old Town Spring. A group of log and milled lumber buildings and temporary tent structures included stores, a news depot, saloons, and lodging houses. Note the piles of hand-hewn rail cross ties.

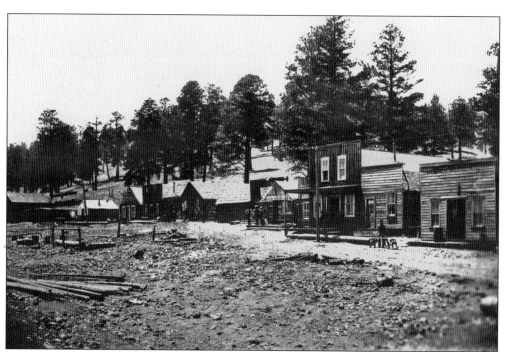

Here is another view of Old Town looking west toward Mars Hill. Fires plagued the little settlement's wood and canvas structures. In 1886, the railroad decided to construct the first depot on flatter land about a mile to the east.

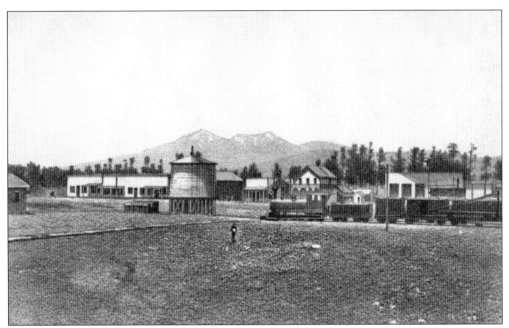

A lithograph, drawn from a photograph by J. C. Burge, shows New Town in 1884. From left to right are the stores of J. R. Kilpatrick, J. H. Wilson and Son, H. H. Hoxworth and Company, and Daggs Brothers and Clark. The front of the Flagstaff Hotel is obscured by the railroad water storage tank.

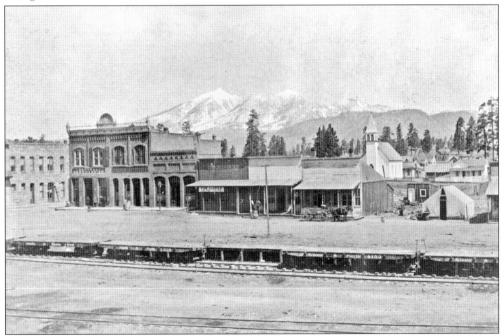

Fires also plagued the wooden structures in New Town. By 1894, fire-resistant stone and brick buildings were springing up along Railroad Avenue. Shown on the left are the Bank Hotel and the G. A. Bray building, and at center right is the Methodist Episcopal church. (Courtesy of Arizona Historical Society/Tucson AHS 53695.)

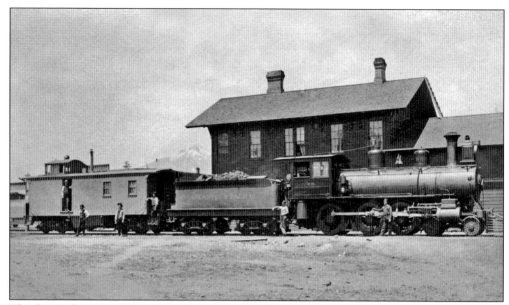

The first Atlantic and Pacific Railway depot was built in 1886 and housed both passenger and freight facilities. The second story was used as quarters for train crews. The depot burned to the ground in 1889. (Courtesy of AHS-Pioneer Museum AHS-PM.0040.00016.)

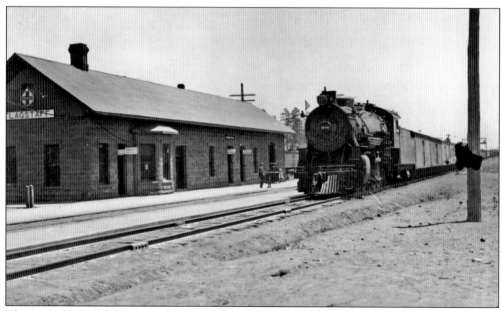

The second railroad depot was built in 1890. Constructed of red Moenkopi sandstone quarried nearby, the new building served as a freight depot, a passenger station, and a telegraph office. It now serves as an office for the Burlington Northern Santa Fe Railway. (Courtesy of NAU Cline Library NAU.PH.412.1.35.)

This 1920 photograph shows travelers waiting at the railroad depot. The Pine Hotel, owned by Alf Dickinson, appears in the background. Nearby was a public drinking fountain offering "99.6 per cent pure waters from the eternal snows of the San Francisco Peaks."

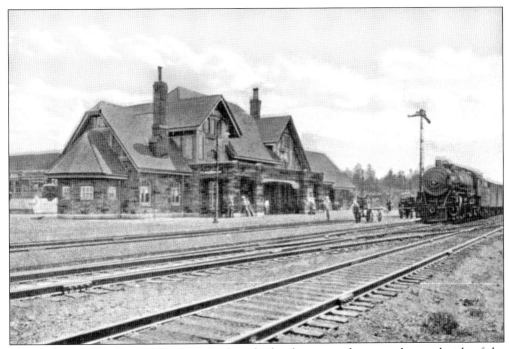

The Atchison, Topeka, and Santa Fe Railway built a large new depot on the north side of the tracks between San Francisco and Beaver Streets in 1925. A formal opening ceremony took place on January 5, 1926, with agent T. A. Stahl officiating.

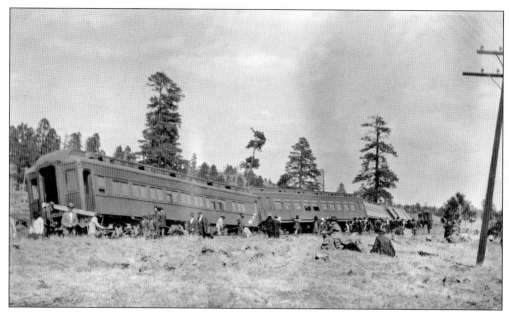

Early-day trains were prone to derailments because of unstable and sometimes hastily constructed roadbeds and weak, uneven wooden cross ties. This view shows the wreck of a passenger train just west of Flagstaff in the spring of 1917. (Courtesy of AHS-Pioneer Museum AHS-PM.0703.00179.)

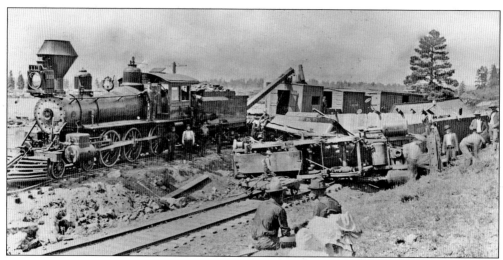

Collisions with livestock and other animals also posed a threat to early railroad trains. This view from the 1890s shows a freight train derailed after colliding with a horse near the Arizona Lumber and Timber Company mill. A salvage and repair train has just arrived beside the wrecked cars. (Courtesy of AHS-Pioneer Museum AHS-PM.0004.00001.)

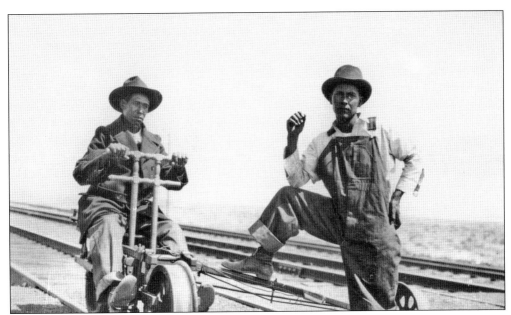

Rails and roadbeds required constant maintenance and repair. Crews traveled the rails in small, human-powered push cars. In this view, Santa Fe workers, including Benito Mayorga (left) and an unidentified man, pose for the camera on the rails just east of Flagstaff. (Courtesy of NAU Cline Library NAU.PH.97.33.2.14.)

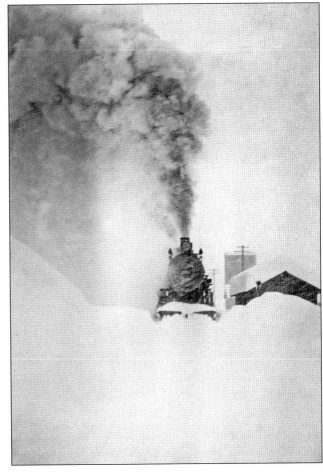

Heavy snows in northern Arizona sometimes disrupted rail traffic. Special snowplow engines were brought in to clear the tracks and to keep the trains running. Here a plow engine strains to clear the snow near the Santa Fe depot. This big snow occurred during the winter of 1915–1916.

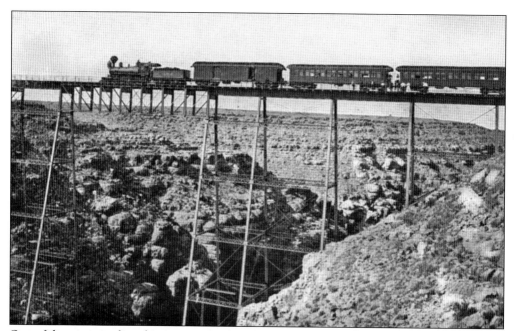

One of the greatest obstacles to construction of a railroad across northern Arizona was Canyon Diablo, a deep canyon about 35 miles east of Flagstaff. A high, steel bridge was designed, fabricated, and erected in 1881–1882, allowing the first train to reach Flagstaff in August 1882.

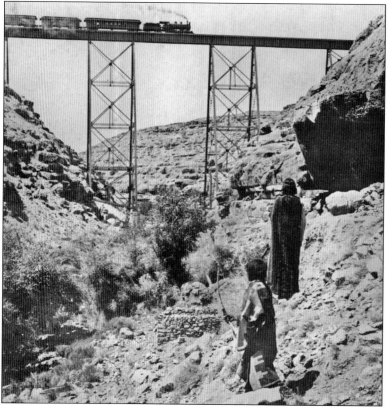

The coming of the railroad brought northern Arizona's native peoples out of their extreme isolation and toward the mainstream of American culture. For the first time, manufactured goods and a wide array of foodstuffs became available, markets opened up for Native American arts and crafts, and access to medical care and education began to grow. The lives of the Native American were changed forever.

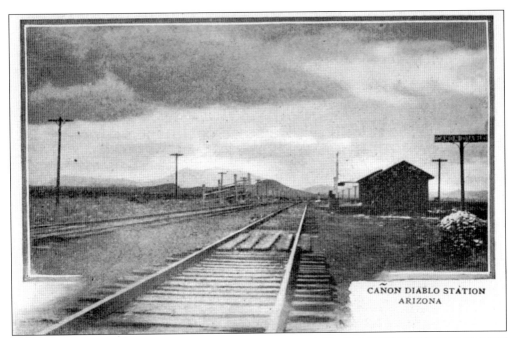

CAÑON DIABLO STATION
ARIZONA

This view shows the Canyon Diablo station on the east side of the chasm. For many years, this was the starting point for tourists traveling by horse-drawn coaches to the Hopi mesas to witness Hopi ceremonials.

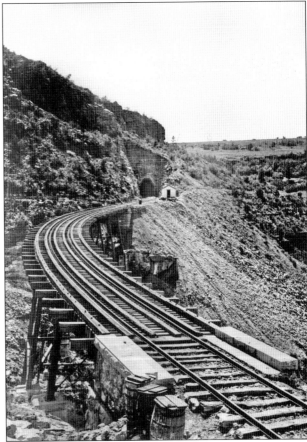

West of Flagstaff, the railroad line had to descend the Mogollon Rim, the great escarpment cutting across northern Arizona. This view shows the high trestle bridge and tunnel at Johnson's Canyon between Williams and Ash Fork. The tunnel entrances are constructed from Moenkopi sandstone, and the ceiling inside the curving, nearly mile-long tunnel is lined with huge steel plates.

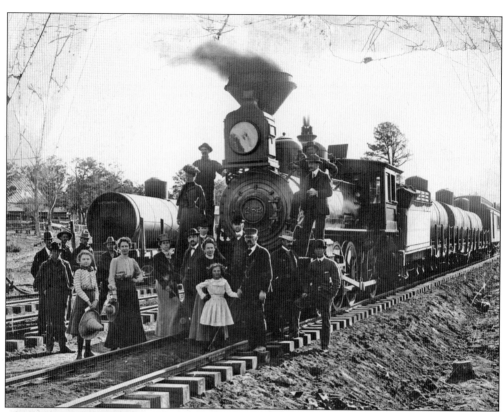

This view shows the arrival of the first passenger train at the South Rim of the Grand Canyon on September 17, 1901. The Grand Canyon rail line left the main Santa Fe transcontinental line at Williams. Trains brought tourists to the new depot just below the Fred Harvey Company's El Tovar Hotel, also completed in 1901. (Courtesy of AHS-Pioneer Museum AHS-PM.0111.00001.)

The Santa Fe Railway and its hospitality partner, the Fred Harvey Company, aggressively promoted tourism to the Grand Canyon and to the southwest's Native American country. Harveycars would transport tourists from various points on the railroad to scenic areas and Native American pueblos across northern Arizona and New Mexico.

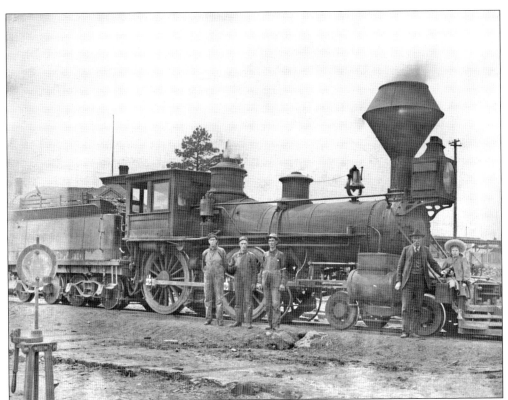

Pictured above are Arizona Lumber and Timber Company's Engine No. 1 and its crew. Second from right is Edward T. McGonigle, longtime general superintendant of the Arizona Lumber and Timber mill and later president of the Flagstaff Lumber Manufacturing Company. (Courtesy of NAU Cline Library NAU.PH.676.71.)

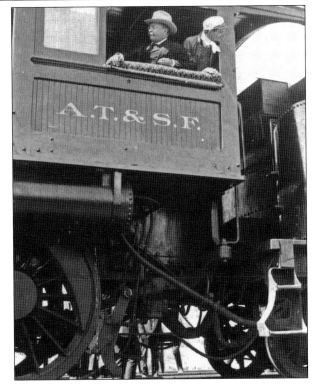

The commander in chief takes over as "engineer in chief." Pres. Theodore Roosevelt (left) is shown in the cab of a Santa Fe locomotive on a trip to the Grand Canyon and California in 1903. At the South Rim, Roosevelt spoke eloquently about the need to protect the Grand Canyon for future generations.

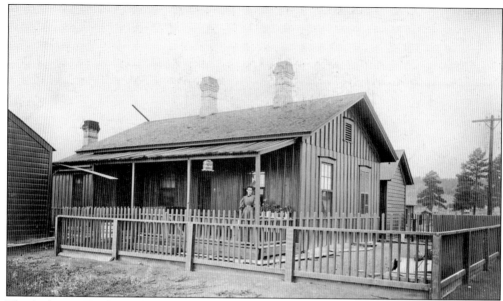

The Atchison, Topeka, and Santa Fe Flagstaff section house is seen here in 1895. The house served as a maintenance facility and crew quarters after the first depot burned down. It was located on the south side of the tracks between San Francisco and Beaver Streets next to the railroad's huge, steel, water storage tank. (Courtesy of AHS-Pioneer Museum AHS-PM.0750.00002.)

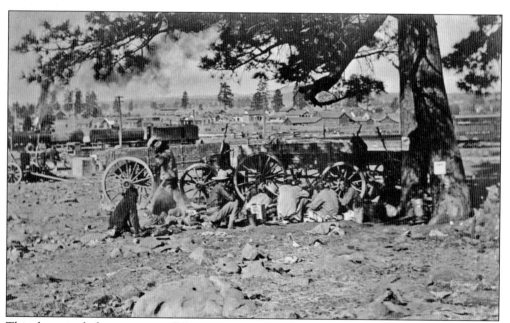

This photograph shows a group of Navajos camping beside the busy Santa Fe rail yards in Flagstaff in the summer of 1913. Water-tank cars appear on the left, and a cattle car is shown on the right. (Courtesy of NAU Cline Library NAU.PH.93.21.233.)

Four

STICKS AND STONES

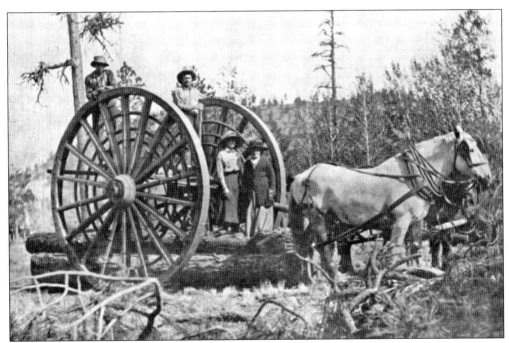

This 1912 view shows, from left to right, two unidentified men, Mrs. Al Doyle (Sarah), and Bertha Smith Kennedy visiting a logging camp west of Flagstaff to get a firsthand look at logging operations. Kennedy was a schoolteacher and principal at Emerson School.

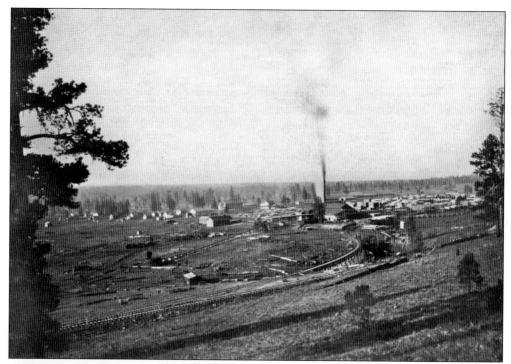

The Ayer Lumber Company mill is pictured in this 1888 photograph. The view looks toward the south of the flank of Mars Hill with the 7:00 a.m. whistle signaling the beginning of the workday. This is the earliest known photograph of the Ayer mill and yard. (Courtesy of Brian and Lois Chambers.)

Michael J. Riordan is shown here in a photograph from 1886. Along with brother Timothy and half-brother Denis, Riordan operated the Arizona Lumber and Timber Company mill from 1887 until his death in 1930 at the age of 64. In 1933, this mill was sold to Joseph C. Dolan. (Courtesy of Brian and Lois Chambers.)

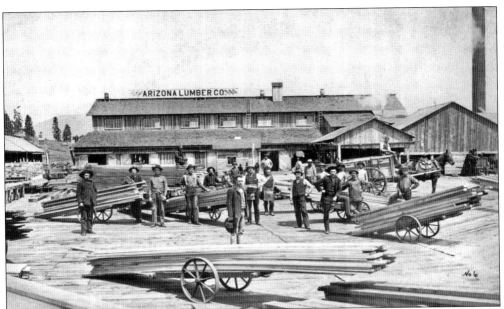

This view by Flagstaff photographer C. Osborn shows workers in the yard of the Arizona Lumber Company in 1887, the year the mill was purchased by Denis M. Riordan. Daily capacity of the mill was 60,000 board feet. (Courtesy of Brian and Lois Chambers.)

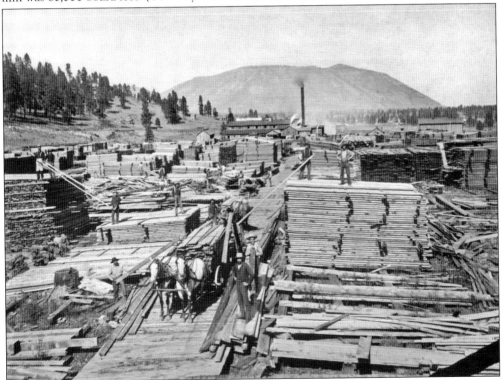

Stacks of pine lumber air-dry in the yard of the Arizona Lumber Company in 1887. Longtime mill superintendent Edward T. McGonigle is shown in the center foreground. This view was taken by Los Angeles photographer A. D. Merchand. (Courtesy of Brian and Lois Chambers.)

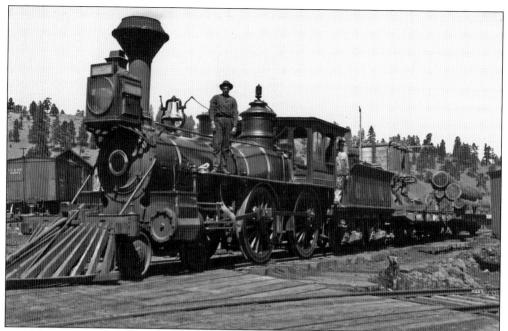

Another Riordan enterprise was the Central Arizona Railroad, which was formed to transport logs to the mill from the surrounding forests. At one time, the Riordans planned to extend the railroad to the copper mines at Globe. (Courtesy of Brian and Lois Chambers.)

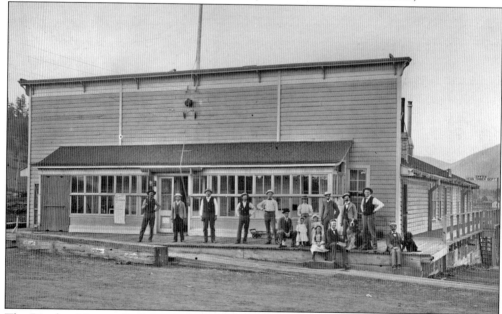

The Riordan Mercantile Company commissary and offices are pictured here in 1899. Milton, the company town next to the Arizona Lumber and Timber Company mill, provided housing for workers as well as a company store. Pictured from left to right are (standing) four unidentified, Clarence Spellmire, Mrs. Michael Riordan (Elizabeth), Arthur Riordan, Blanche Riordan, two unidentified, and Timothy Riordan; (seated) Michael J. Riordan, Mary Riordan, Fred Sisson, and unidentified. (Courtesy of Brian and Lois Chambers.)

Pictured here is an exhibit of tools and products from the Arizona Lumber and Timber Company mill. Products included shingles, lath, fence pickets, fancy moldings, handrails, and curtain rods. Timothy Riordan stands on the right with E. T. McGonigle on the left. (Courtesy of Brian and Lois Chambers.)

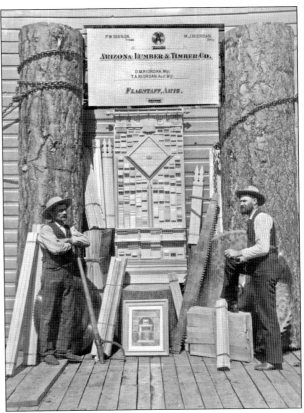

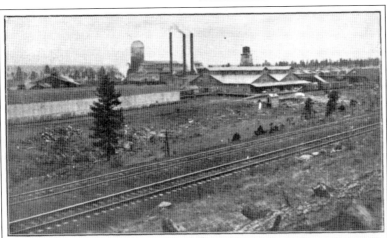

T. A. RIORDAN, President M. J. RIORDAN, Secretary

ARIZONA

LUMBER & TIMBER COMPANY

Manufacturers of

NATIVE PINE LUMBER, PROPS, STULLS

Piling, Ties, Lagging, Boxes,
Lath, Shingles, Sash
and Doors

FLAGSTAFF, - - - - - - - ARIZONA

This is a 1912 advertisement for the Arizona Lumber and Timber Company. By this time, the mill was offering a huge variety of native ponderosa pine products. Around this time, the company employed more than 250 people.

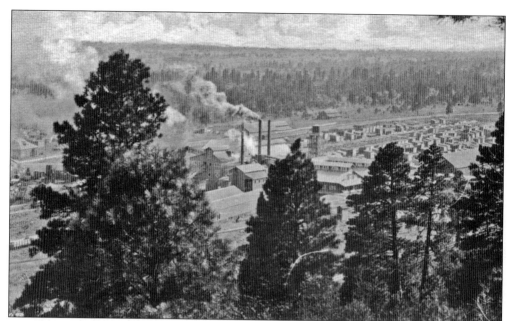

The Arizona Lumber and Timber Company mill is pictured here in the 1920s. The mill was in full production, sawing up to 150,000 board feet per day.

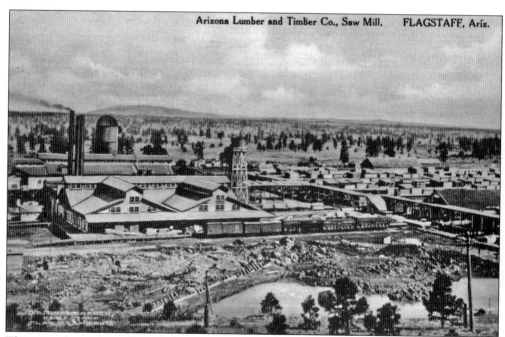

Arizona Lumber and Timber Co., Saw Mill. FLAGSTAFF, Ariz.

This view shows the millponds between the Santa Fe tracks and the mill. Logs were dumped into the ponds and kept for several days to remove dirt, mud, and rocks. Such debris would dull or ruin saw blades.

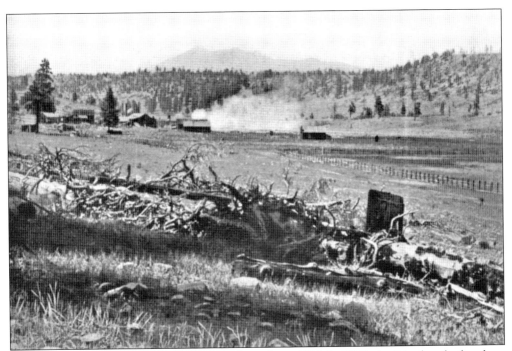

The Greenlaw mill in Clark's Valley is seen here about 1900. In 1904, the Riordans built a dam, which flooded the valley and inundated the Greenlaw mill site. The resulting lake was named for Tim Riordan's daughter Mary.

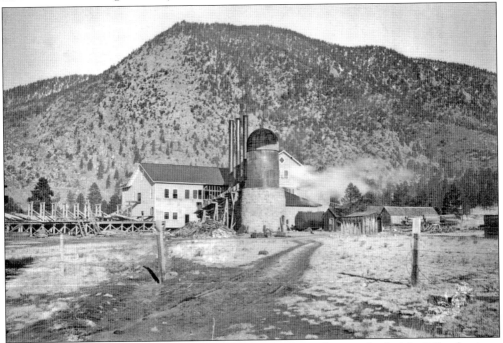

Pictured is the Greenlaw mill at the Cliffs in east Flagstaff near the site of today's La-Z-Boy furniture store. The Greenlaw mill, with a daily capacity of 75,000 board feet and employing 150 workers, later became a Riordan subsidiary. (Courtesy of Jack and Billie Faye Beamer.)

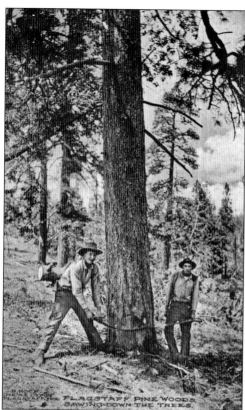

Two loggers are shown about to cut down a large pine tree. Two-man crosscut saws, called felling saws, were used to down the tree. Bucking saws were used to cut the tree into lengths.

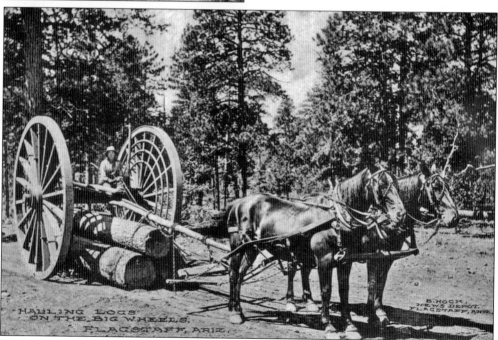

Horse-drawn carts dragged logs to waiting log trains. These single-axle carts, referred to as "big wheels," were eventually replaced by motorized skidders.

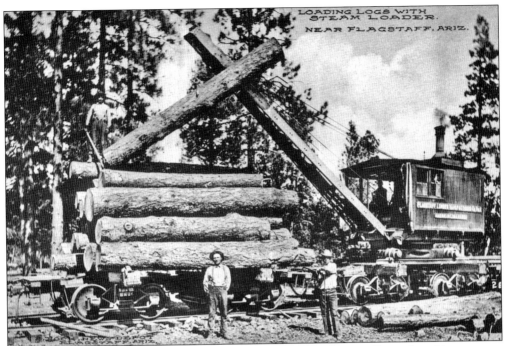

At the railroad, steam loaders were used to hoist logs onto flatcars. Examples of log cars are preserved beside the Burlington Northern Santa Fe office in downtown Flagstaff.

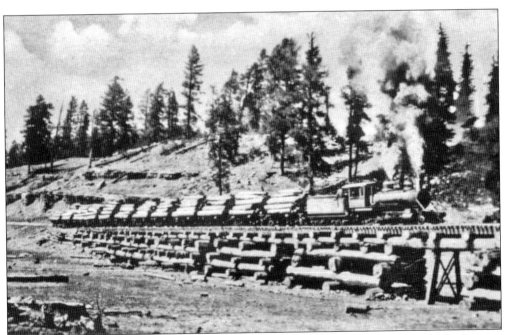

Railroads were the primary means of transporting logs from the forest to the mill. Tracks were laid through the forests over a wide area surrounding Flagstaff. Remnant railroad beds are still evident in some areas.

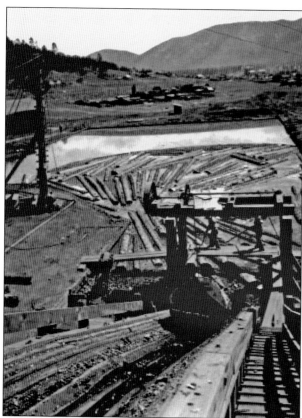

A huge conveyor brought logs from millponds up to the saw room. Dimensioned lumber would come out the other side of the mill, ready for sorting and stacking in the drying yard. (Courtesy of U.S. Forest Service, Coconino National Forest.)

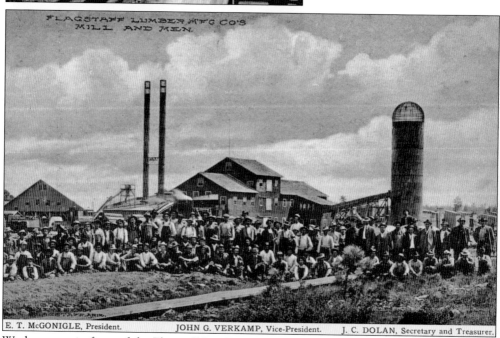

Workers pose in front of the Flagstaff Lumber Manufacturing Company mill on today's Butler Avenue about 1914.

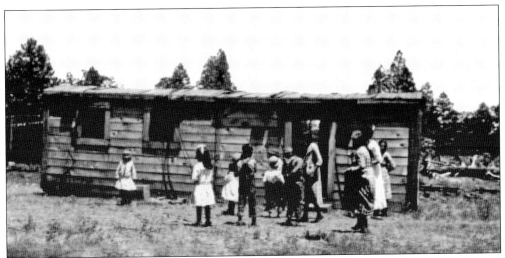

The school at the Greenlaw mill in Clark's Valley is pictured around 1900. Children of loggers and mill workers were schooled in small structures that were transported to mill sites on railcars. (Courtesy of U.S. Forest Service, Coconino National Forest.)

ARIZONA SANDSTONE COMPANY

PROPRIETORS OF THE

FLAGSTAFF QUARRIES

OFFICE: 126 W. 4TH ST., SANTA ANA, CAL. FLAGSTAFF, ARIZ.

OFFICERS:

A. J. Padgham, President ; Daniel Halladay, Vice-President ; O. M. Robbins, Sec'y and Manager ; Commercial Bank, Santa Ana, Treasurer

DIRECTORS:

Daniel Halladay, M. D. Halladay, A. J. Padgham, A. B. Case, A. R. Rowley

A large outcropping of Moenkopi sandstone near the southern edge of McMillan Mesa was first exploited by the Atlantic and Pacific Railway for stone for bridge footings. The quarry was expanded in the late 1880s, and the Arizona Sandstone Company of Los Angles took over its operation. Flagstaff attorney T. G. Norris was the company's local representative.

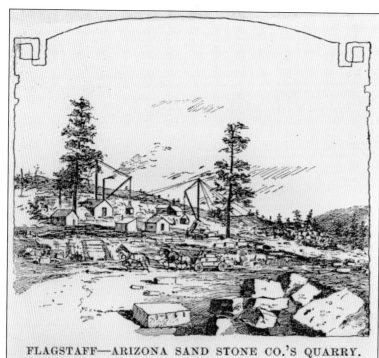

FLAGSTAFF—ARIZONA SAND STONE CO.'S QUARRY.

This line drawing showing the quarry's operations appeared in Chicago's illustrated magazine, the *Graphic*, on February 27, 1892. At that time, the quarry employed more than 50 workers.

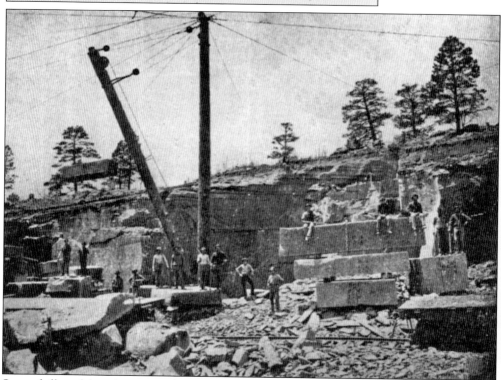

Steam drills and derricks were used in the quarry. More than 500 railcars of the Flagstaff sandstone were used in the construction of the Los Angeles County Courthouse in 1889–1890. The stone was also used in the construction of many public and commercial buildings in Flagstaff.

Five

RANCHERS, MERCHANTS, AND BANKERS

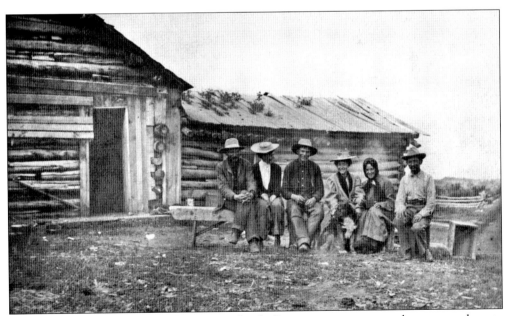

Cedar Ranch, headquarters for the Arizona Cattle Company, was a stop on the stagecoach route to the Grand Canyon. The Babbitt Brothers purchased it in 1899. This view shows C. O. Bar Ranch range boss Billy Babbitt (right) hosting a group of tenderfeet about 1901.

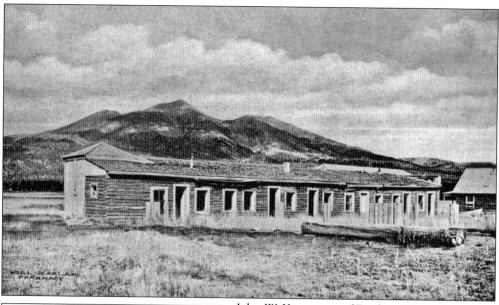

THE ARIZONA CATTLE COMPANY.

JOHN C. De La VERGNE,
President.

ELLIS WAINWRIGHT,
Managing Director.

HENRY R. Von der HORST,
Vice-President.

CHARLES L. RICKERSON,
Treasurer.

H. W. GUERNSEY,
Secretary.

——— RANGE, ———

SAN FRANCISCO MOUNTAINS,

YAVAPAI COUNTY,

ARIZONA TERRITORY.

$1,000 REWARD!!

This Company offers a reward of ONE THOUSAND DOLLARS for the arrest and conviction of any person stealing cattle, horses or mules, the property of this Company, or for unlawfully tampering with the brands on them.

This reward is offered independent of, and in addition to, the reward offered by the Mogollon Live Stock Protective Association.

——— BRAND: ———

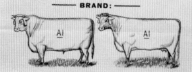

The cattle are branded on the left side **A** one, with bar beneath **A1**, with the ears jingle-bobbed, as per cut above.

Horses and mules are branded **A** one on the left shoulder: **A1**.

The foregoing brands will be kept up.

Some of our cattle are branded on the left side **X** with a bar above: **X**, with the ears jingle-bobbed.

The larger portion of our cattle are at present branded with the following brands:

The cattle are branded on the left side **A** one: **A1**; wattle on each cheek, slit in each ear: also **X**, with bar above: **X**; left ear boxed, right ear swallow-forked.

The company has increased its herd this season (1886) by the purchase of cattle branded, some with **⅄.H.P.L** connected **⅄P**, some with **O** with bar beneath: **O**; also all branded **O, V, O**, connected **⅋P**, various ear marks. These cattle have nearly all been branded with our brand, viz: **A1**.

B. B. BULLWINKLE, AGENT

AND GENERAL MANAGER, FORT RICKERSON.

P. O. FLAGSTAFF, ARIZONA.

John W. Young, son of Brigham Young, built the so-called Fort Moroni in the early 1880s as a base for cutting rail ties for the Atlantic and Pacific Railway, which was being laid westward from Albuquerque. The fort later became the headquarters for the Arizona Cattle Company and was renamed Fort Rickerson after the company's vice president.

In 1885, John W. Young's Moroni Cattle Company was purchased by the Arizona Cattle Company, based in New York. The new company's brand was the A1 Bar. Never profitable, the Arizona Cattle Company was sold to the Babbitt Brothers in 1899.

This 1890s picture shows C. O. Bar Ranch cowboys preparing to ship cattle by rail to market at Dodge City, Kansas. The corrals were located south of the Santa Fe railroad tracks near today's SCA Tissue plant on Butler Avenue.

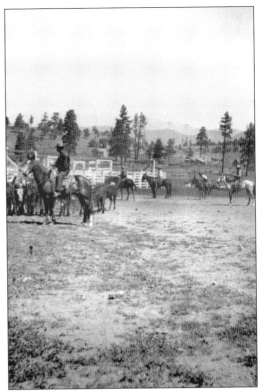

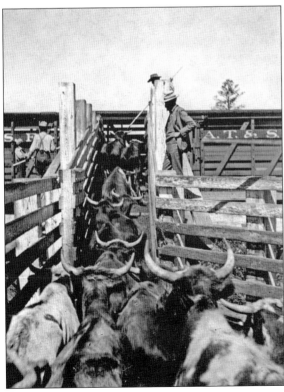

C. J. Babbitt (far right) inspects cattle going up a loading chute and onto Santa Fe railcars. The cattle were shipped to markets in both Kansas and California.

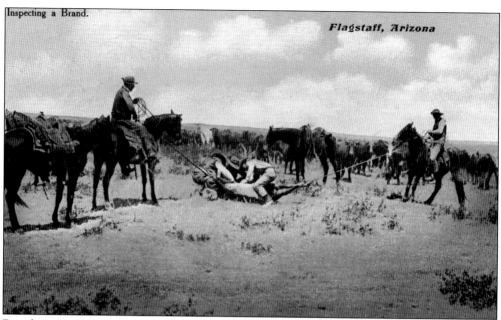

Flagstaff, Arizona

Brands were a way of proving ownership and preventing rustling. The Arizona Livestock Sanitary Board registered brands and sent brand inspectors to check the validity of brands on the range.

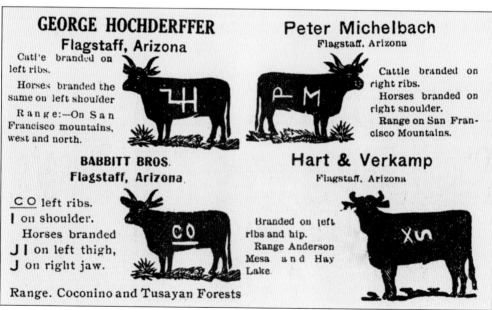

Part of the brand registration process required publication of brand information for cattle and sheep in the legal notices section of newspapers. Here are brand notices of four Flagstaff cattle ranchers published in the *Coconino Sun* on May 26, 1911.

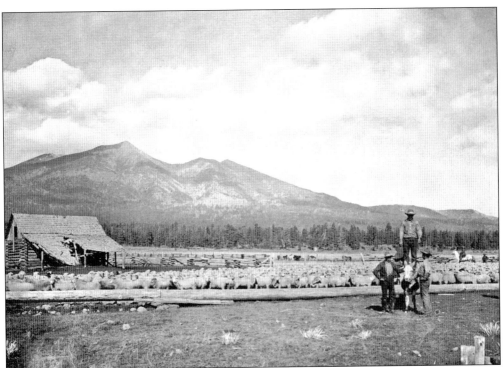

Sheep were an important part of northern Arizona's livestock industry from the earliest days. This photograph shows the flocks gathered in Fort Valley at wool-clipping time in 1916.

DAGGS BROS.,
Sheep Breeders and Wool Raisers,
FLAGSTAFF, ARIZONA.

American Merino Rams, Thoroughly Acclimated, For Sale.

The Daggs brothers, Jack, Frank, Pete, and Bob, were prominent sheepmen in Flagstaff in the 1880s. They brought large bands of sheep from California and spread them across the range around Flagstaff. At one time, their flocks were said to number more than 50,000.

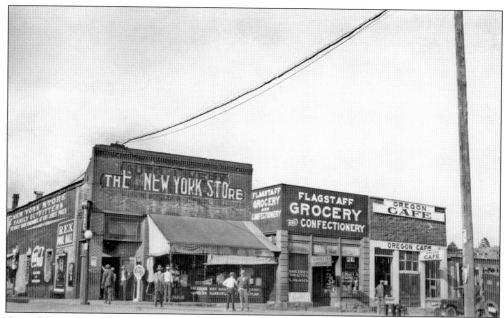

One of the first merchants in Flagstaff was Peter J. Brannen. First establishing a store in a tent beside the railroad tracks at Old Town, Brannen soon moved to New Town and built a stone structure on the north side of Railroad Avenue at San Francisco Street. This photograph by Earle Forrest shows the same corner in 1926. (Courtesy of Museum of Northern Arizona, MS-143-2981.)

← THE →

Pioneer Store,

FLAGSTAFF, ARIZONA.

Offering Big Inducements to Purchasers.

CALL ON

P. J. BRANNEN

—FOR—

BARGAINS!

Coal, Bacon, Ham and Lard,
Canned Goods, Flour, Wagons,
Sugar, Salt,
Buggies and Carriages OF EVERY DESCRIPTION,
Coal Oil, Corn and Oats,
Hay and Barley.

P. J. Brannen was one of Flagstaff's leading merchants until 1895, when he closed his store and sold his remaining stock and fixtures to the Babbitt Brothers. Brannen remained active in church and civic affairs for the remainder of his life.

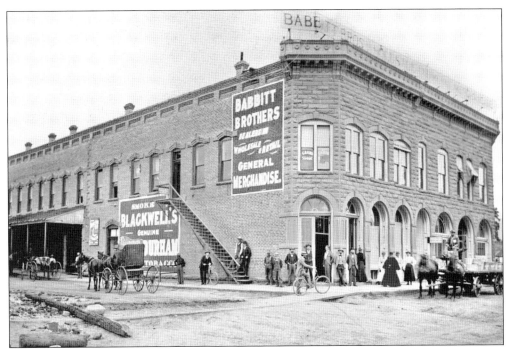

The Babbitt Brothers general store is pictured here in the autumn of 1897. At the front entrance, from left to right, are George Babbitt (with beard), Tom Rickel, John Verkamp (in doorway), and C. J. and David Babbitt. At one time, this was the largest general store in Arizona.

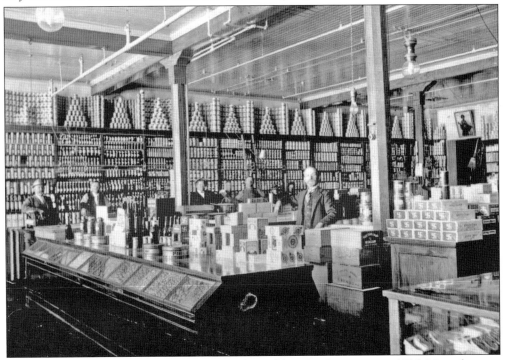

This view shows the grocery department of the Babbitt Brothers store in 1895. Note the neat stacks of canned food and the bins of beans and nuts.

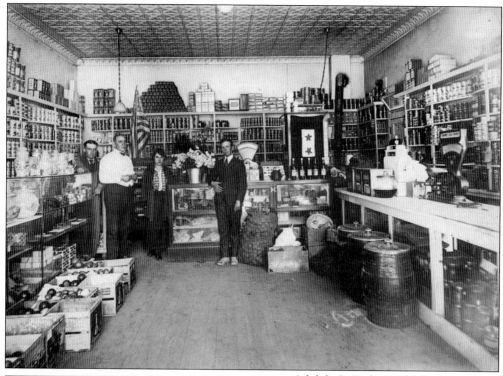

Adolph G. Bader established a delicatessen, bakery, and confectionery at 20 North Leroux Street during World War I. This view shows Bader (second from left) and his daughter Katherine with two unidentified store clerks. (Courtesy of Claudine Randazzo.)

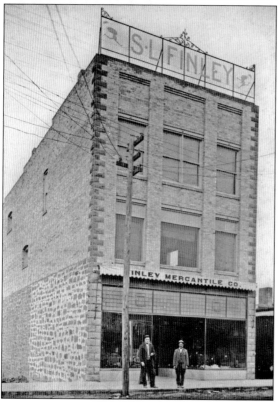

Sam L. Finley (right) and Walter Martin (left) stand in front of Finley's three-story mercantile building in 1915. Finley served as Flagstaff's mayor from 1916 to 1918. He sold his building and business to W. H. Switzer in 1920. (Courtesy of NAU Cline Library NAU.PH.485.11.)

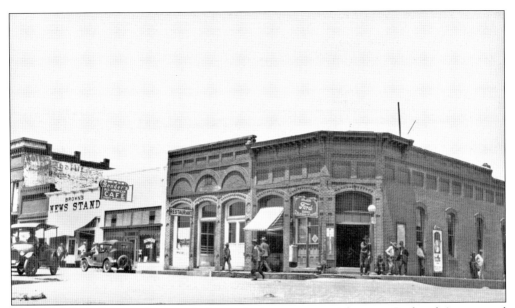

This 1926 Earle Forrest photograph shows the busy commercial area at Railroad Avenue and San Francisco Street. The corner Vail Building still stands but has been covered with an art deco stucco facade. (Courtesy of Museum of Northern Arizona MS-143-2979.)

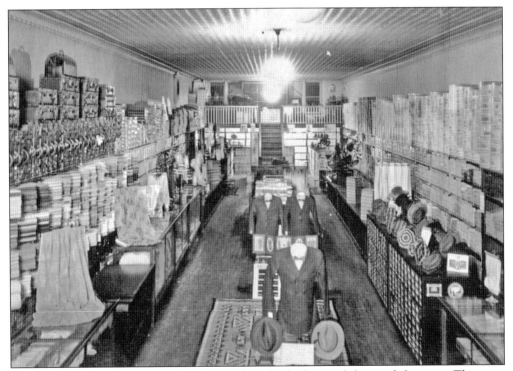

Julius Herman came to Flagstaff in 1899 and established a retail dry-goods business. This view shows the interior of the Herman store at 11 East Aspen Avenue in the Sanderson Building. The Mountain Oasis restaurant now occupies this space. (Courtesy of Maury Herman.)

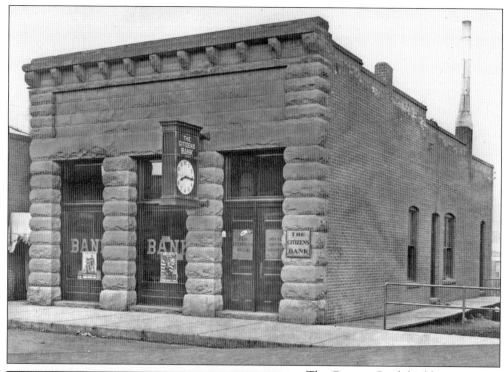

The Citizens Bank building on North Leroux Street is pictured in 1918. The building still stands, but the stone facade has been removed, and a shed roof has been extended over the sidewalk.

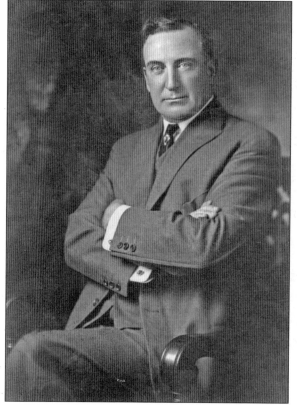

Thomas E. Pollock, an Iowa banker, came to Flagstaff in 1896 to direct the Arizona Central Bank. Pollock served as mayor from 1901 to 1904 and was involved in ranching, timber, and real estate businesses. (Courtesy of Ann, Kay, and Tom E. Pollock III.)

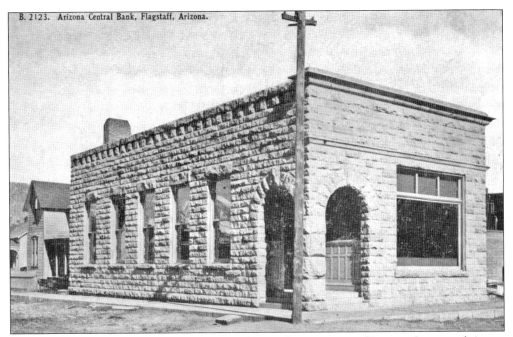

B. 2123. Arizona Central Bank, Flagstaff, Arizona.

The Arizona Central Bank was located on the northeast corner of Leroux Street and Aspen Avenue. The bank advertised itself as the "oldest in northern Arizona." The building was enlarged in 1910.

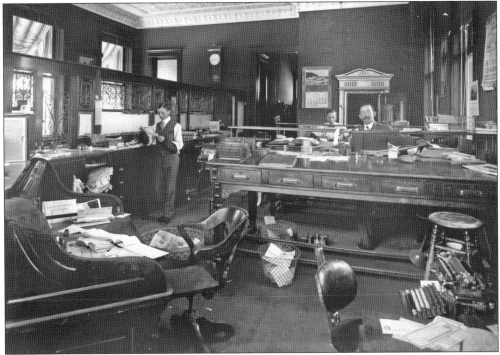

A remarkable interior view of the Arizona Central Bank from June 1909 shows a teller and clerks in their cluttered work area. The clock reads, "U.S. Observatory Time Hourly by Western Union Company."

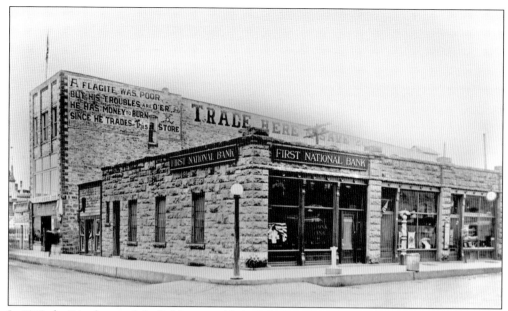

In 1917, the Riordans and the Babbitts established the First National Bank. The bank was housed in the former U.S. Post Office space at 23 East Aspen Avenue.

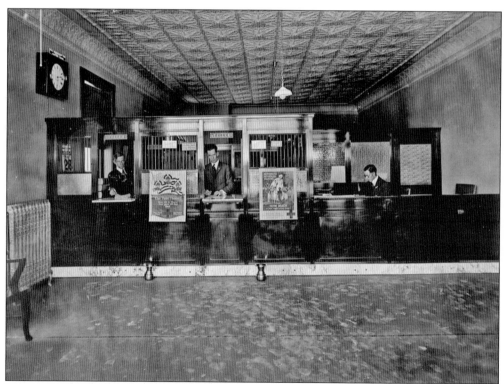

This interior view of the First National Bank was captured on May 28, 1918. Note the World War I bond drive posters. Cashier Woeber Smith is shown at right. The other two workers are unidentified. (Courtesy of Brian and Lois Chambers.)

Six

HOMES AND
COMMUNITY LIFE

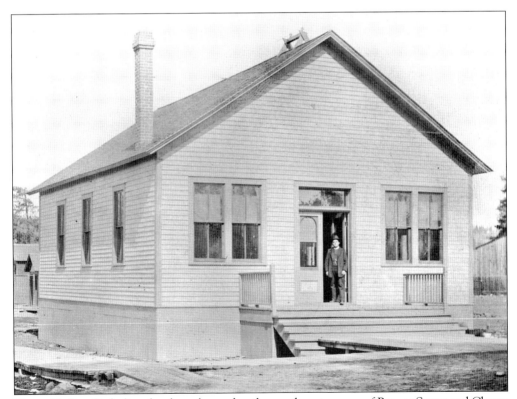

Flagstaff's first Catholic school was located at the northwest corner of Beaver Street and Cherry Avenue. It is pictured here in the 1890s.

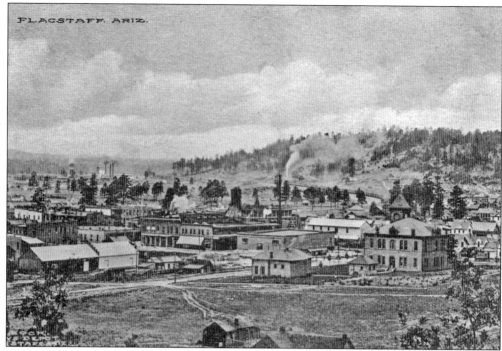

This view from about 1915 shows Flagstaff alive with activity. Smoke pours from the lumber mill smokestacks, and the westbound Santa Fe train chugs up the grade along Mars Hill.

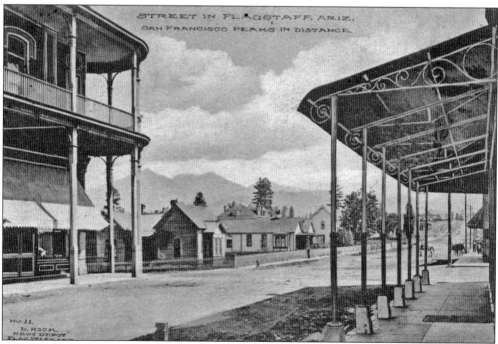

This view, looking at the northwest corner of Leroux Street and Aspen Avenue, shows the balcony of the Weatherford Hotel and several Leroux Street residences. Leroux Street was named for Antoine Leroux (1801–1861), a scout and guide for several early expeditions across northern Arizona.

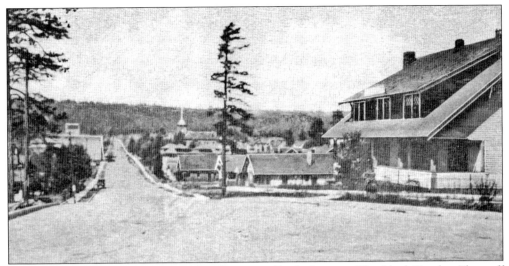

This view toward Mars Hill was taken from east Birch Avenue. The Ideal Hotel, a Flagstaff landmark built by Eric Denver, appears down the street on the right.

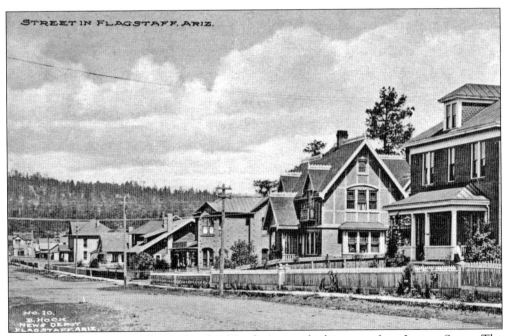

This 1916 postcard shows the north side of Birch Avenue looking west from Leroux Street. The first home on the right is the Allen Doyle House, and the George Hoxworth residence appears three houses farther west.

The Thomas E. Pollock residence on North Leroux Street is pictured here around 1904. The home was built by Elias S. Clark, a prominent Flagstaff attorney and politician who ran unsuccessfully for governor in 1926 against George W. P. Hunt.

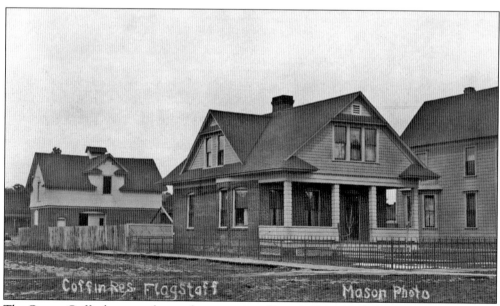

The George Coffin house at the northwest corner of Leroux Street and Elm Avenue is seen here. Coffin had come to Flagstaff in the 1890s, establishing himself as a dealer in sheet metal and home appliances and furnishings.

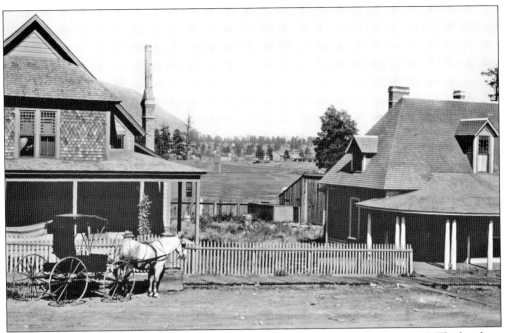

The Michael J. and Timothy A. Riordan homes at Milton are pictured here in 1896. The brothers later hired architect Charles Whittlesey to design two new residences connected by a common billiards room. This new residence became today's Riordan Mansion State Park. (Courtesy of Brian and Lois Chambers.)

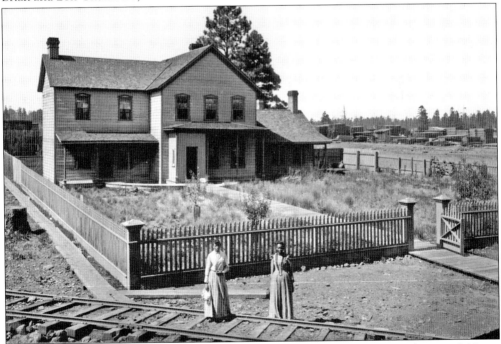

This is the backyard of the "White House," D. M. Riordan's original residence at Milton. A Mrs. Shepperd (right) and daughter Minnie are pictured just outside the fancy picket fence in this 1888 photograph. (Courtesy of Brian and Lois Chambers.)

The George Babbitt home was designed by architect Charles Whittlesey, who also designed the El Tovar Hotel and the Riordan mansions. The Babbitt home was located on the mesa just northeast of the downtown. It was destroyed by fire in 1960.

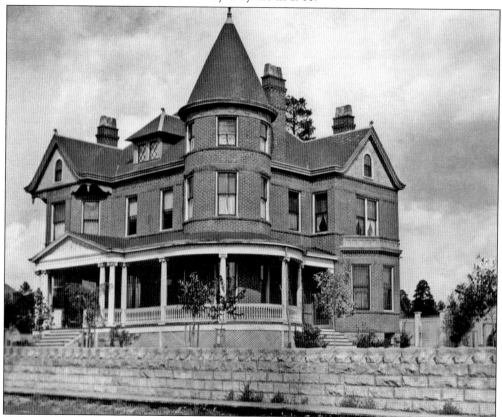

The Charles J. Babbitt home on the southeast corner of Beaver Street and Cherry Avenue was built in 1900 in the Queen Anne style. The structure burned down in 1964. The large stone wall still surrounds the property, now occupied by the Theatrikos Theatre.

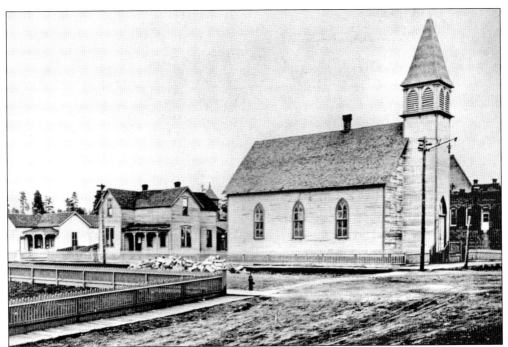

Built in 1886, the Methodist Episcopal church was located on Aspen Avenue—then known as Church Avenue—near Leroux Street. The church's steeple appears in many early photographs of Flagstaff.

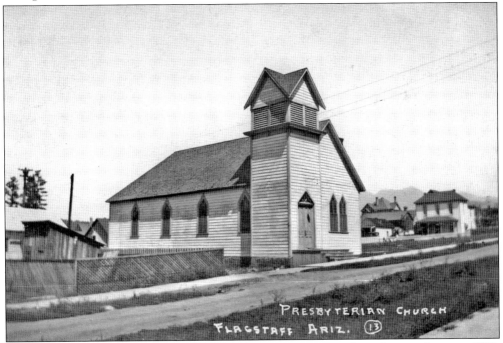

The Presbyterian church was built on San Francisco Street across from the courthouse in 1892. In 1927, it was moved to South San Francisco Street and Dupont Avenue, and renamed La Iglesia Methodista. The church still stands, and its steeple has been restored.

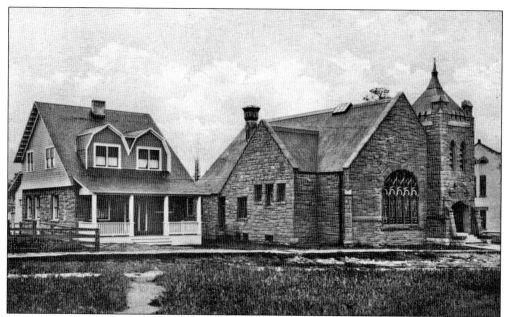

The Federated Community Church was built on Sitgreaves Street and Church Avenue (now Aspen Avenue). The Methodists had outgrown their church downtown and moved into their beautiful new sandstone building in 1907.

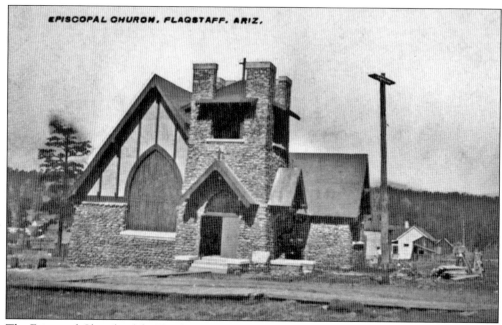

The Episcopal Church of the Epiphany on north Beaver Street at Elm Avenue was built in 1912 using native malpais rock. The beautiful interior woodwork was executed by Flagstaff master cabinetmaker and carpenter Edward Mills.

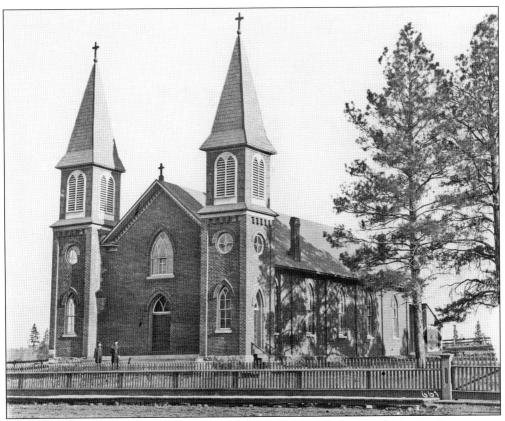

Flagstaff's first Catholic church was built in 1887–1888 on land donated by Peter J. Brannen on Brannen Avenue and South Elden Street. The first Mass occurred on Christmas Eve 1888, so the church was named the Church of the Nativity.

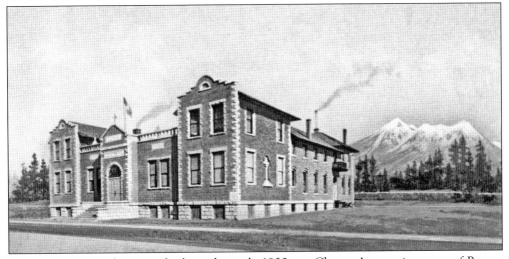

St. Anthony's Academy was built in the early 1900s on Cherry Avenue just west of Beaver Street. By 1911, the Catholic parish at the Church of the Nativity abandoned the inconveniently located Brannen location and, for the next 15 years, attended services in the chapel at St. Anthony's School.

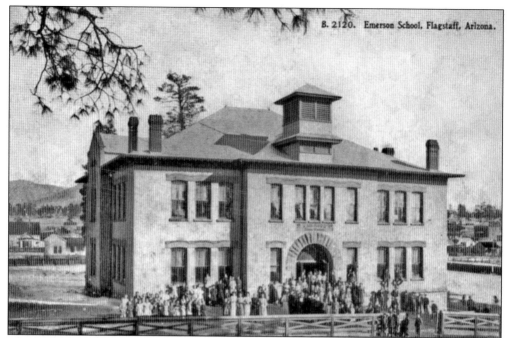

The Emerson School was built in 1895 and combined elementary grades and a high school. The school building stood until the early 1980s when it was demolished and replaced by the Flagstaff City–Coconino County Public Library.

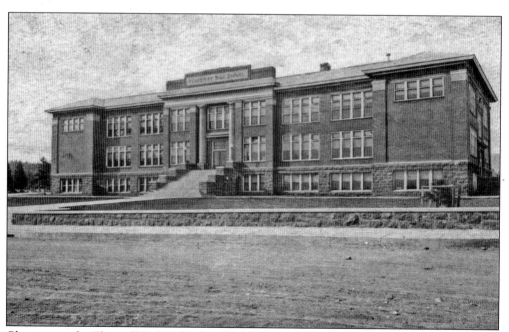

Classes started at Flagstaff High School in the fall of 1923 with 94 students in attendance. John Q. Thomas was the school's second principal, serving until 1946. The building was demolished in 1970.

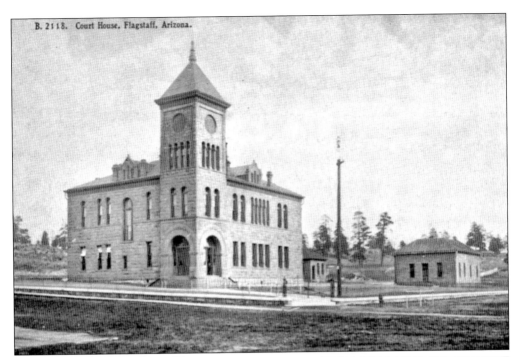

The Coconino County Court House was constructed in 1894 from local Moenkopi sandstone. Expanded in 1925, the facility was recently restored to its original splendor.

George Hochderffer, the town marshal, stands in front of Flagstaff's first town hall. Built in 1895, the town hall was on the east side of Leroux Street, midway between Railroad and Aspen Avenues. The building combined a jail, a firehouse, and city offices. (Courtesy of AHS-Pioneer Museum AHS-PM.0032.00026.)

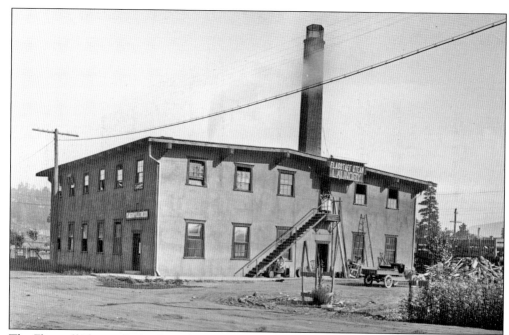

The Flagstaff Electric Light Company was constructed on West Phoenix Avenue in 1913. The plant used wood and waste sawdust from the lumber mills to generate electricity. At one time, steam from the plant was piped to several downtown buildings to provide heat. (Courtesy of AHS Pioneer Museum AHS-PM 0365.00001.)

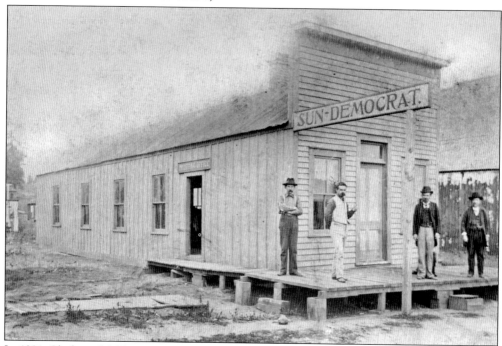

In 1891, Clarkson M. Funston purchased the *Arizona Champion* newspaper and renamed it the *Coconino Sun*. For a short interval in 1896–1897, the paper was called the *Flagstaff Sun-Democrat*. This 1897 view includes Funston (second from right) and three unidentified men.

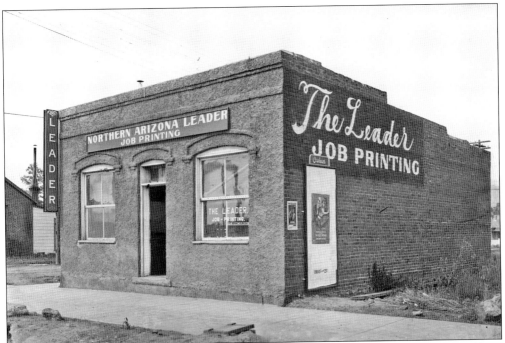

Flagstaff democrats E. T. McGonigle, Fred Colter, George Babbitt, and Sheriff William Dickinson started the *Northern Arizona Leader* in 1916. The *Leader* ceased publication in 1922. Note the Orpheum movie posters in this 1917 view. (Courtesy of Arizona Historical Society/ Tucson 43997.)

In 1889, the Riordans built a handsome residence for Fred Sisson, a longtime Arizona Lumber and Timber Company officer. After Sisson's death in 1908, the Sisson home was converted into the Milton Hospital to serve mill employees and the rest of the community.

In 1908, Coconino County built a hospital for the care of the indigents. Known as the "poor farm," the building sits on a knoll beside Fort Valley Road. Today it houses the Arizona Historical Society Pioneer Museum.

The Flagstaff Undertaking Parlor was on Aspen Avenue just east of the Monte Vista Hotel. The building, constructed about 1915, was demolished in the 1970s.

Seven

WINTER AND WATER

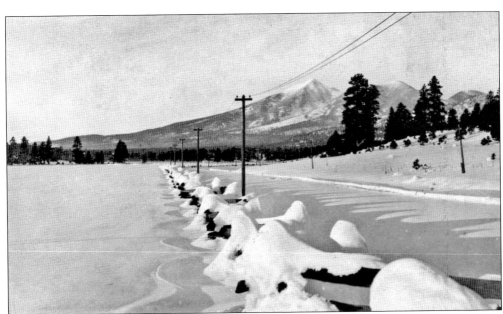

Above is a winter scene on Fort Valley Road in the 1920s. This photograph was taken from a point near today's Flagstaff High School football field. In the summertime, the area at left was part of the Pinewood Dairy pasture.

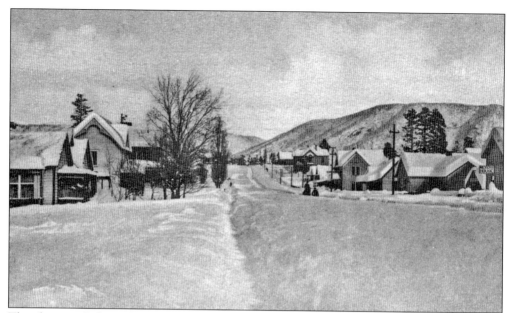

This photograph shows the view looking up Leroux Street after a big snow. For many years, the street was closed after snowstorms to allow sledding on the hill seen at the center of this picture.

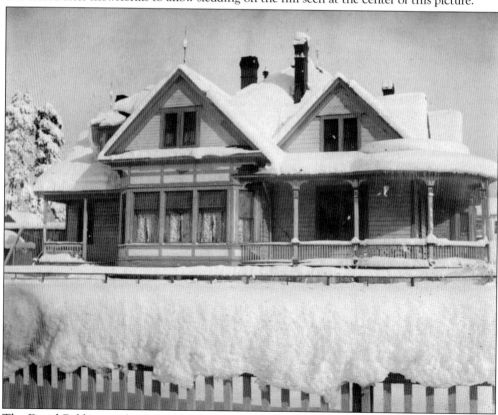

The David Babbitt residence on North Beaver Street is pictured during the big snowstorm of 1916. The house still stands, although it has been considerably modified.

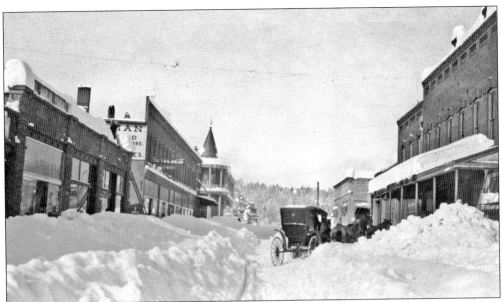

The winter of 1915–1916 saw almost 130 inches of snowfall, much of that coming in one storm in late December 1915. This view is looking west on Aspen Avenue with men shoveling snow off the roof of the Marler Pharmacy and the Western Union cable office.

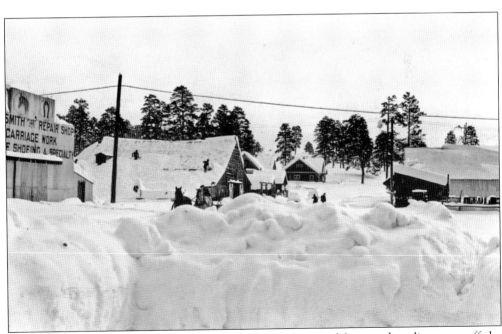

A view after the big snowstorm looks east on Aspen Avenue. Men are shoveling snow off the roof of the Babbitt livery stable, the site of today's U.S. Post Office.

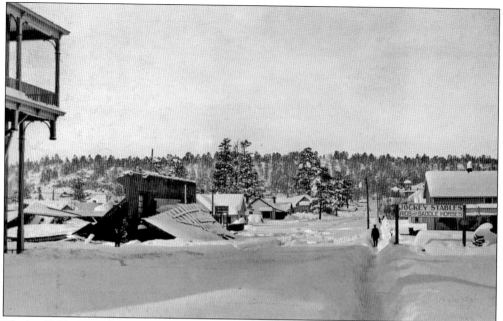

The big 1915 snow collapsed the roof of the Majestic Theater on West Aspen Avenue on New Year's Eve. The movie projection equipment was moved to a temporary theater in the former Babbitt garage and was christened the Empress Theatre. In 1917, the rebuilt Majestic was reopened as the Orpheum Theater.

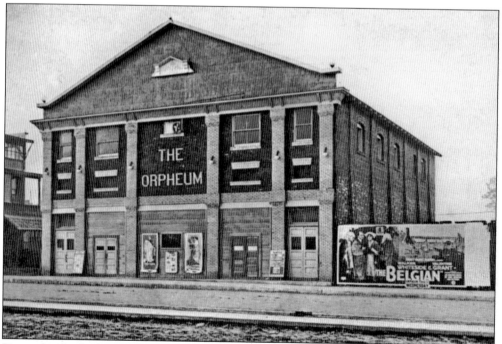

Pictured is the Orpheum Theater in the early 1920s. J. J. and Mary Costigan managed the theater, installing talking movie equipment in 1926. Al Jolson's *The Jazz Singer* was the first "talkie" to show in Flagstaff.

This view is looking east on Aspen Avenue during the 1915 storm. At the center is the garage that would temporarily become the Empress Theatre.

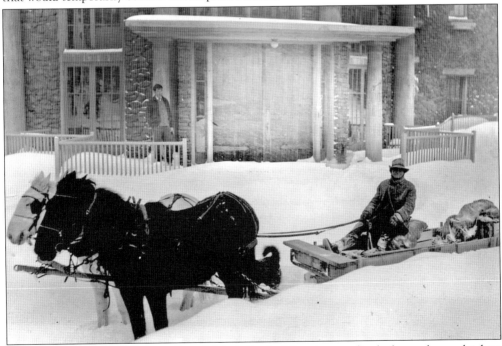

This undated photograph shows Peter J. Michelbach delivering supplies by horse-drawn sleigh to the Lowell Observatory. Michelbach came to Flagstaff in 1887 and homesteaded on Hart Prairie. (Courtesy of Marilyn Michelbach Coy.)

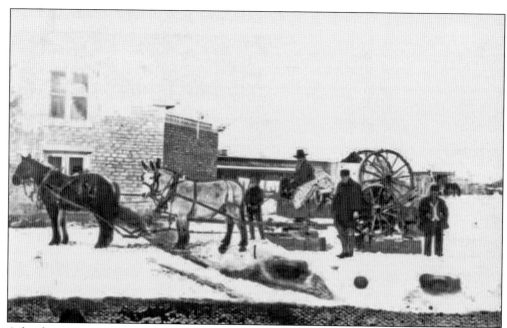

A freight wagon is pictured delivering supplies to the Tuba Trading Post after a big snow in 1910. The wagon wheels have been removed and replaced with skids to allow the wagon to travel through the snow.

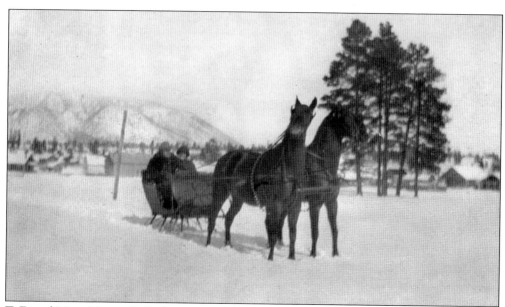

T. E. and Mary Morton Pollock are pictured here in their horse-drawn sleigh about 1910. The Pollocks were married in Iowa in 1906. (Courtesy of Ann, Kay, and Tom E. Pollock III.)

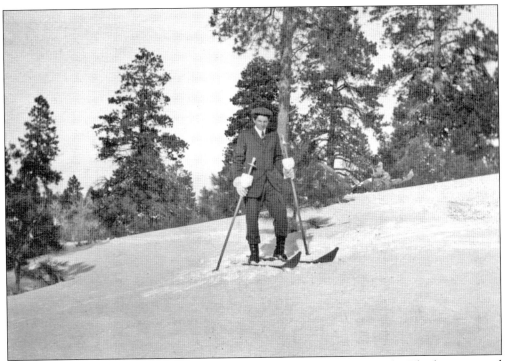

An early-day cross-country skier poses on the slopes of the San Francisco Peaks. The first organized ski area was launched in 1938 and later became known as the Arizona Snow Bowl.

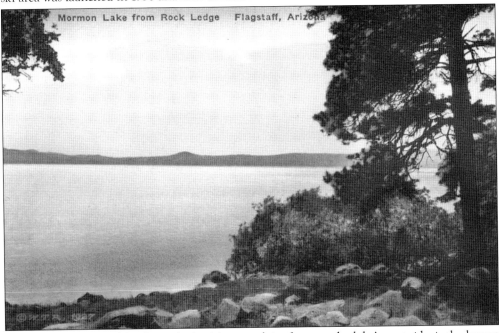

Mormon Lake from Rock Ledge Flagstaff, Arizona

Mormon Lake, named for the early-day Mormon dairy farm on the lake's west side, is the largest natural lake in Arizona. Shallow and prone to drying up entirely in periods of drought, the lake has been up to 15 feet deep in wet periods. Some drainages to the lake were diverted to the south, decreasing the available water to the lake.

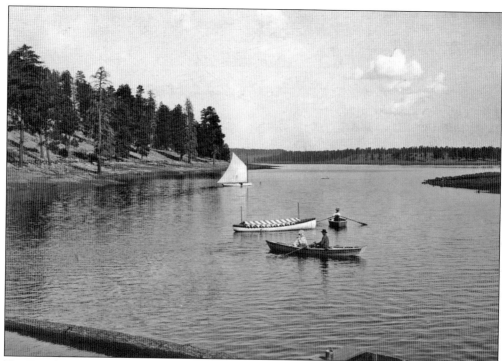

Tim Riordan had the idea to place a small dam across Walnut Creek at the head of Clark's Valley. The dam was a success; a much larger dam was constructed in 1904. The resulting lake was named for Riordan's daughter Mary. (Courtesy of Brian and Lois Chambers.)

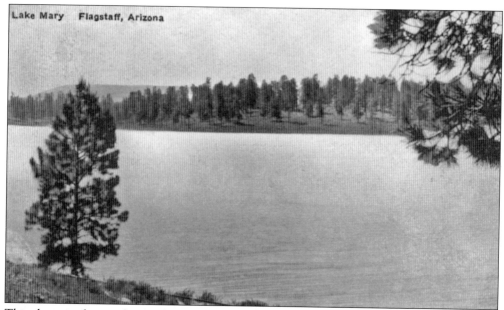

Lake Mary Flagstaff, Arizona

This photograph provides another view of Lake Mary. In 1941, a second dam was built upstream from the 1904 Riordan dam, creating Upper Lake Mary.

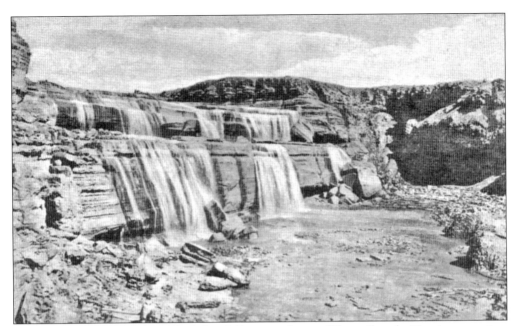

Grand Falls is located on the Little Colorado River northeast of Flagstaff on the Navajo reservation. The falls are 185 feet high and run large volumes of chocolate-colored water during the spring runoff and after summer rains.

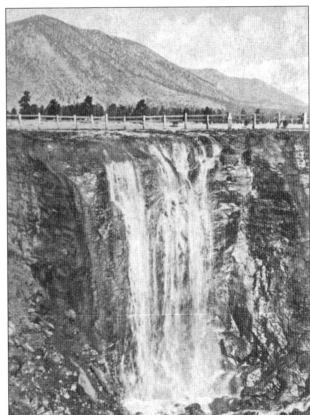

The Bottomless Pits are a deep limestone sink in the bed of the Rio de Flag near Interstate 40 in east Flagstaff. The City of Flagstaff filled in the pits in the 1970s in the interest of public safety.

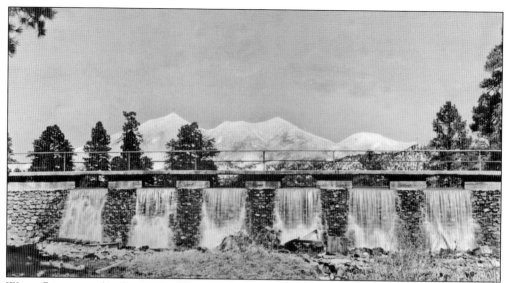

Water flows over the dam at the Frances Short Pond near Thorpe Park. Located near the site of the 1876 flag raising, the pond is fed by Antelope Spring. A pipeline once took water to the railroad tracks to supply Santa Fe steam locomotives. (Courtesy of AHS Pioneer Museum.)

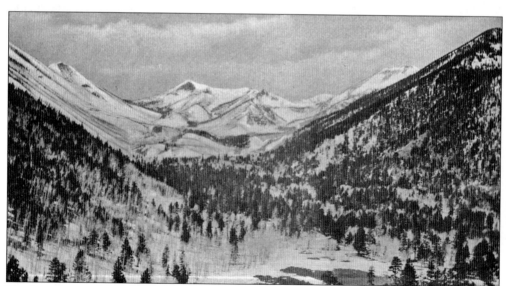

The inner basin of the San Francisco Peaks was an important watershed for collecting Flagstaff's municipal water supply. As early as 1898, efforts were under way to tap the inner basin springs and pipe the water down to a reservoir near town.

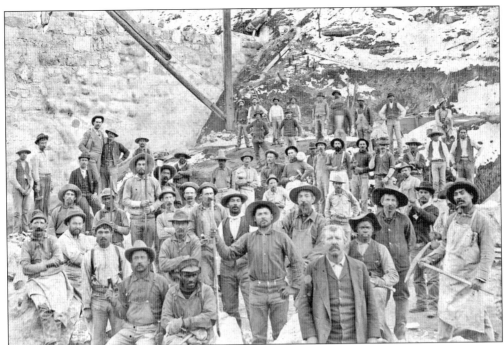

The Atlantic and Pacific Railway needed large amounts of water for its steam locomotives. In the 1890s, the railroad built this sandstone dam across Walnut Creek just upstream from present-day Winona. Water was then piped a short distance to the railroad tracks.

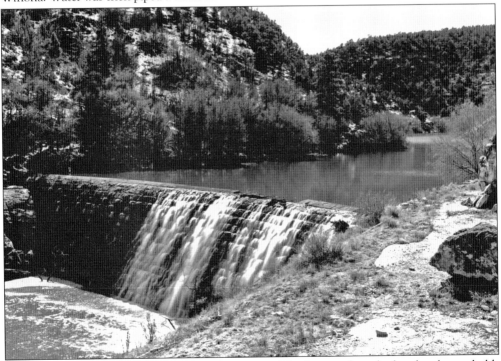

Water tops the Walnut Creek dam after a wet winter. The dam was breached and no longer holds water, but much of the dam structure is still in place.

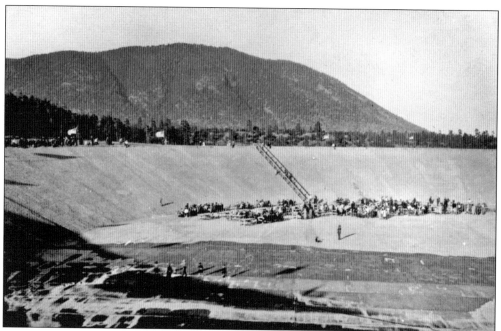

In 1926, a new 52-million-gallon reservoir was added to Flagstaff's water system. This photograph shows crowds gathered at the bottom of the new reservoir for a dedication ceremony on June 18, 1926.

Workers are shown installing Flagstaff's first water mains at Leroux Street and Aspen Avenue in 1898. Some 300 connections were made to this initial water system.

Eight

BYWAYS AND HIGHWAYS

Early-day automobile travel to Native American country was often an arduous and time-consuming undertaking. Here a group traveling across Oraibi Wash to the Hopi villages needs to lend a shoulder to get the cars across the wash.

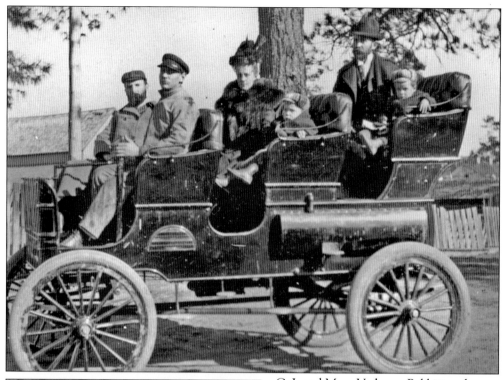

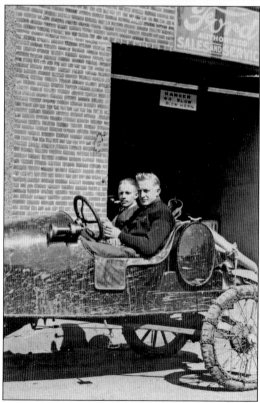

C. J. and Mary Verkamp Babbitt and sons Maurice and Paul are pictured in one of Flagstaff's first automobiles in December 1900. From left to right are (front seat) two unidentified; (middle seat) Mary and Maurice; (back seat) C. J. and Paul. A year later, newspaper editor Winfield Hogaboom and artist Oliver Lippincott made the first trip by automobile to the Grand Canyon.

David Babbitt Jr. and R. J. "Peaches" Hock return from a muddy trip in 1916. In the background is the new Babbitt Brothers garage and dealership.

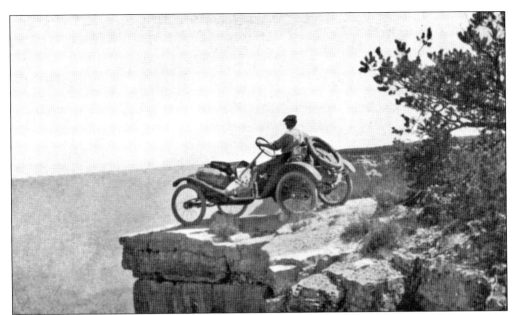

In 1916, the Metz Company of Waltham, Massachusetts, sponsored an automobile trip to the Grand Canyon. Driver O. K. Parker apparently had no fear of heights.

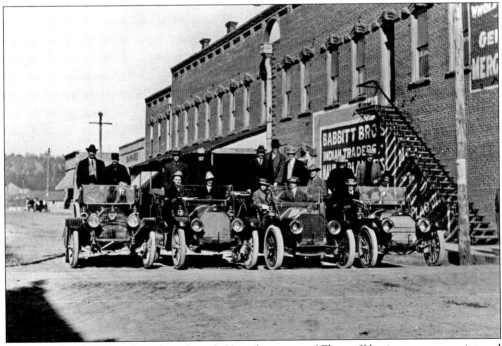

Mayor Richard E. Bongberg (standing, left) and a group of Flagstaff businessmen are pictured here in 1913. Bongberg came to Flagstaff in 1896 from Sweden and worked at the Riordan lumber mill. He served as mayor in 1910–1911 and was elected to the Coconino County Board of Supervisors in 1912.

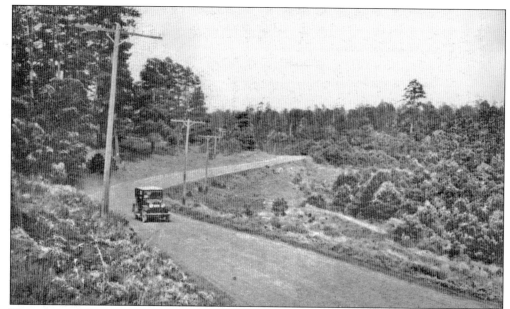

This postcard shows an automobile in the Flagstaff area on the National Old Trails Highway. Established in 1912, the highway was a coast-to-coast system that followed historic trails and roads, and allowed access to scenic attractions along the way.

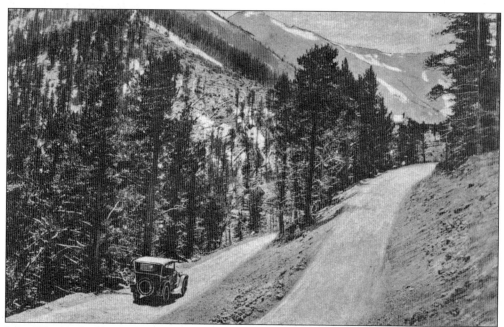

John Weatherford built the San Francisco Mountain Scenic Boulevard. Initially planned as a toll road to the top of the San Francisco Peaks, the first part of the road opened in August 1926. Plagued by bad weather, construction delays, and finally by the great Great Depression, the project ultimately failed. Today the road is a popular hiking trail.

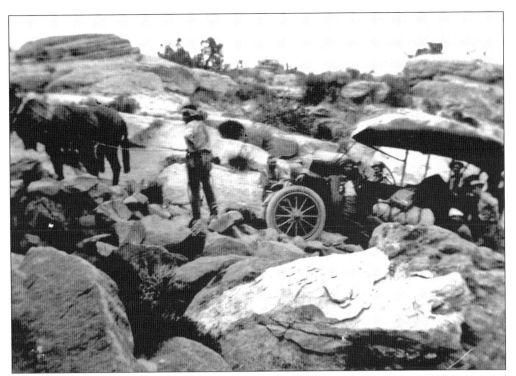

In the days before four-wheel drive, travelers to remote areas of northern Arizona often had to rely on real "horse power."

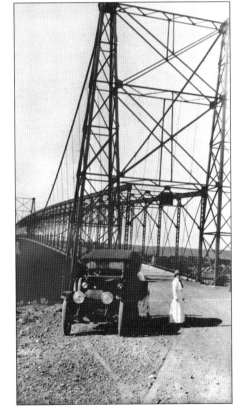

Philomena Babbitt is pictured beside a car at the south end of the new Cameron Bridge. The steel bridge across the Little Colorado River was completed in 1912, permitting easy automobile travel to points such as Tuba City, Kayenta, and the Four Corners region.

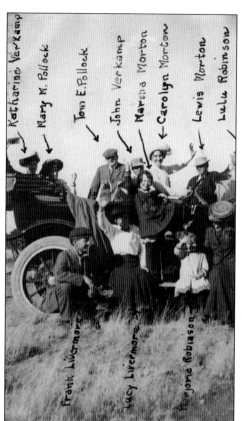

Katharine Verkamp
Mary M. Pollock
Tom E. Pollock
John Verkamp
Marsha Morton
Carolyn Morton
Lewis Morton
Lulu Robinson
Frank Livermore
Lucy Livermore
Marjorie Robinson

The T. E. Pollock family and friends are on an outing in 1925. Others pictured include former A1 Cattle Company foreman Frank Livermore (kneeling, far left) and Grand Canyon merchant John Verkamp (in car, fourth from left). (Courtesy of Ann, Kay, and Tom E. Pollock III.)

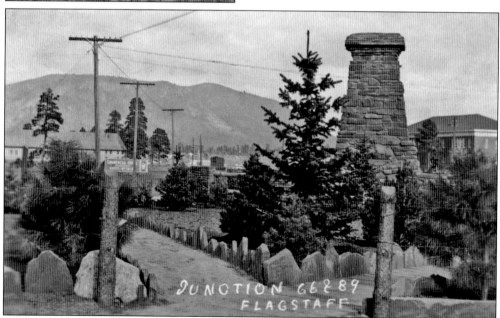

For many years, a tall stone monument marked the junction of U.S. Route 66 and Highway 89 in west Flagstaff. The 1921 Arizona National Guard armory appears in the background at left. Northern Arizona University's Blome Building is at right.

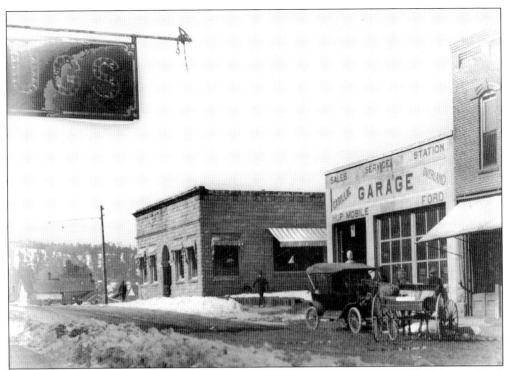

Flagstaff's first garage and dealership sat on Aspen Avenue in 1913. Advertised for sale were Ford, Overland, and Hupmobile automobiles. The Arizona Central Bank appears at left. (Courtesy of AHS-Pioneer Museum AHS-PM.0025.00038.)

Flagstaff's first reinforced concrete building was the Babbitt Ford garage and dealership, constructed in 1915. C. B. Wilson's law office, across from the courthouse, is visible at the lower right.

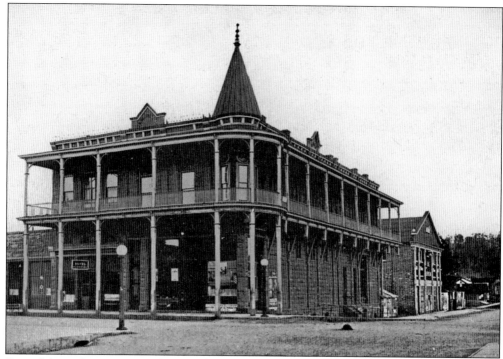

One of the earliest accommodations for early-day travelers was the Weatherford Hotel, built by John W. Weatherford and opened on New Year's Day 1900.

Another early accommodation for tourists was the Commercial Hotel on Railroad Avenue. Built by Sandy Donohue, the structure was originally named the Flagstaff Hotel. The hotel was destroyed by fire in 1976.

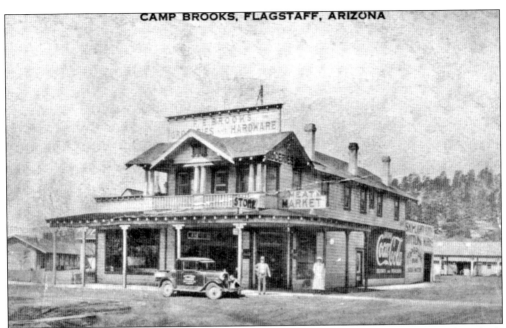

Frank E. Brooks (in doorway) was the proprietor of the Skylight City Bottling Works, which produced Top-O-Peaks brand lemon soda. Camp Brooks, in Flagstaff's west end, included the bottling plant as well as a general store and an auto camp for tourists.

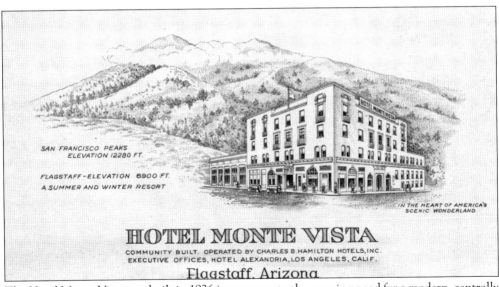

The Hotel Monte Vista was built in 1926 in response to the growing need for a modern, centrally located hotel for tourists and business travelers. The hotel was constructed with subscriptions by many members of the Flagstaff community.

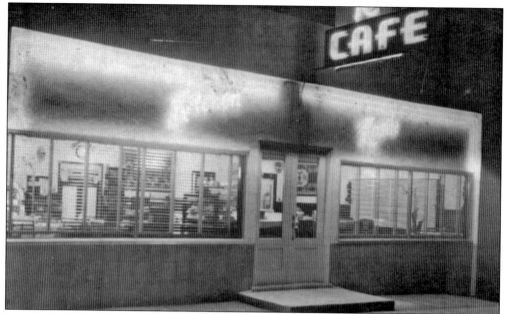

The Kitchen Kastle was a typical Route 66 roadside diner. It was located where Flagstaff City Hall now stands.

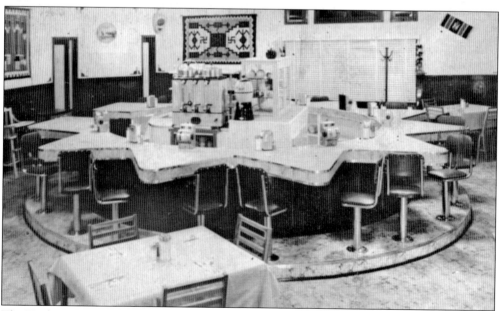

The Kitchen Kastle's interior is pictured here. Note the unique star-shaped lunch counter.

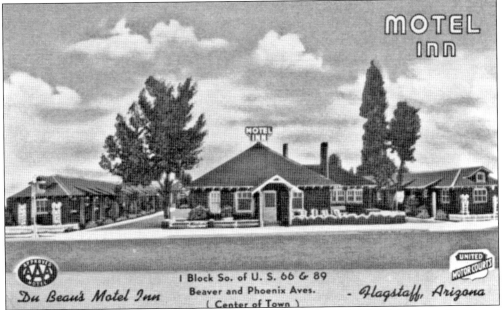

Originally, Route 66 followed today's Phoenix Avenue on the south side of the Santa Fe railroad tracks. Mr. and Mrs. A. E. DuBeau opened the Motel Inn in 1929, advertising it as "a better hotel with garages, designed for the better class of motorists." The name was later changed to the DuBeau Motel.

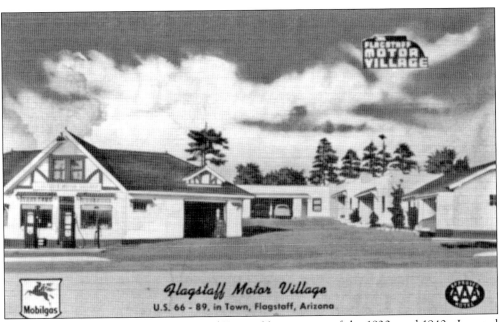

The Flagstaff Motor Village was a typical Route 66 auto court of the 1930s and 1940s. Located on Elden Street and U.S. 66, the site is now occupied by a used-car lot.

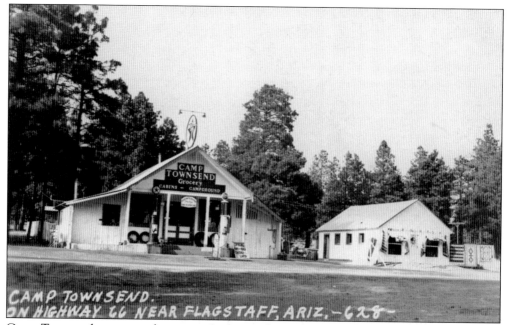

Camp Townsend was a popular tourist facility in the 1920s and 1930s on Route 66 near today's Townsend-Winona Road. The camp provided cabins and a campground, as well as a grocery store and a gas station.

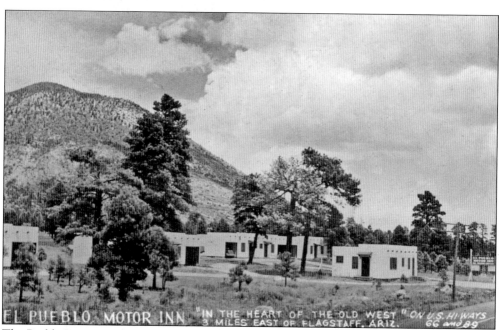

The Pueblo Inn is another typical auto court of the Route 66 era in east Flagstaff. The motel is still in operation.

Nine

HIGHER EDUCATION
AND SCIENCE

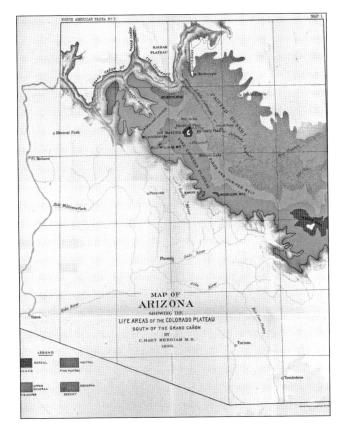

In 1889, C. Hart Merriam conducted the first biological survey of the San Francisco Peaks and the desert along the Little Colorado River. Merriam developed a classification system to describe different life zones from the Arctic-Alpine zone at the top of the San Francisco Peaks down to the Lower and Upper Sonoran zone of the desert areas.

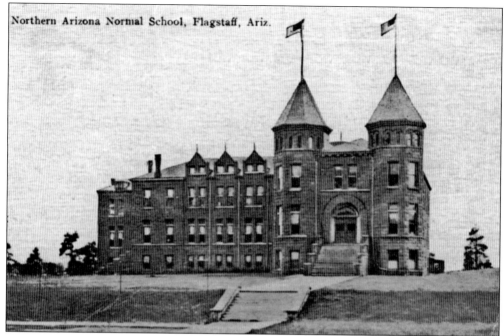

Northern Arizona Normal School, Flagstaff, Ariz.

Old Main was intended originally as a territorial reform school. Local residents lobbied to have the unfinished structure converted to a teacher-training school. The Northern Arizona Normal School was established in 1899.

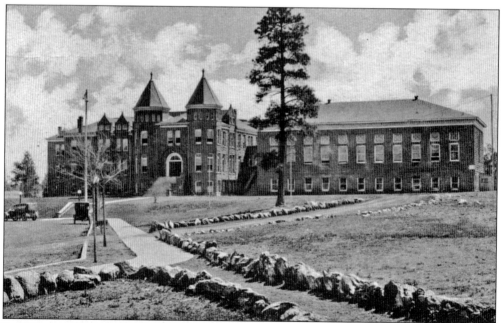

In 1920, an addition, including the Ashurst Auditorium, was made to the west side of Old Main. On July 1, 1925, the Northern Arizona Normal School became the Northern Arizona State Teachers College.

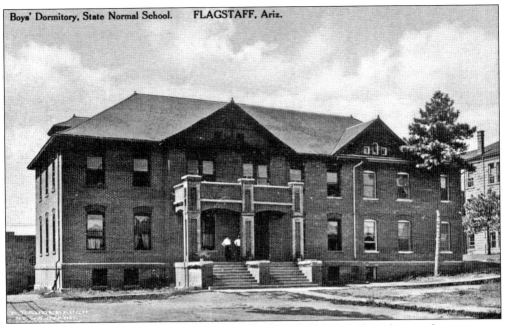

Boys' Dormitory, State Normal School.　FLAGSTAFF, Ariz.

The boys' dormitory was built around 1905 just east of Old Main for boarding students.

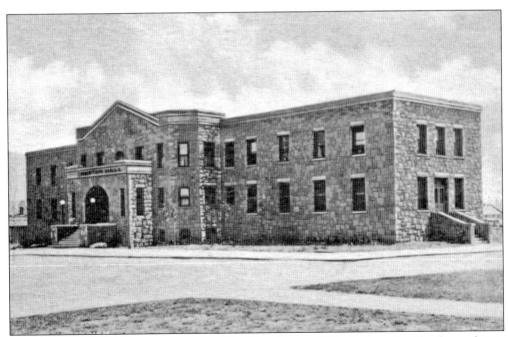

Morton Hall, built about 1915, was named for Mary Morton Pollock, the wife of banker and civic leader Tom Pollock. Mary Pollock was a teacher at the Normal School.

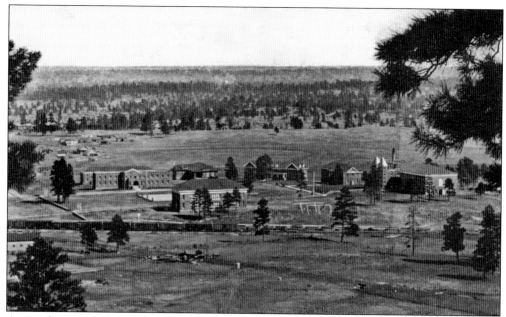

A view from the 1920s shows the quadrangle and growing campus of the teacher's college.

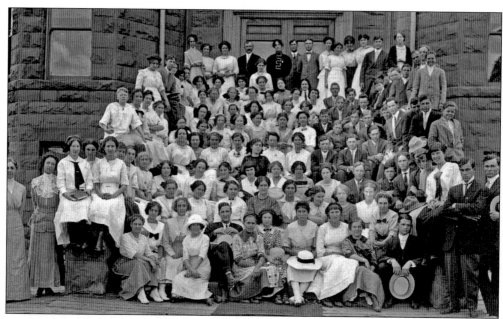

Northern Arizona Normal School's graduating class of 1913 posed on the steps of Old Main. The Normal School, established in 1899 in a building originally intended as a territorial reform school, eventually became Northern Arizona University.

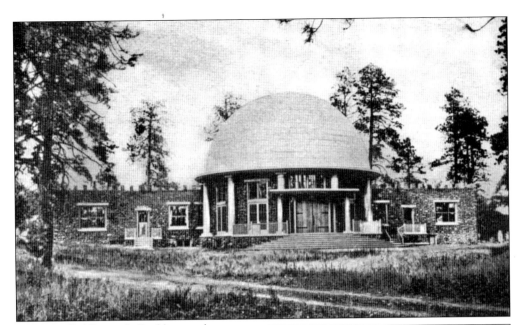

The so-called Rotunda Building at the Lowell Observatory was built in 1915 and housed Percival Lowell's library. Saturn was Lowell's wife, Constance's, favorite planet, so the building was designed to resemble the ringed planet.

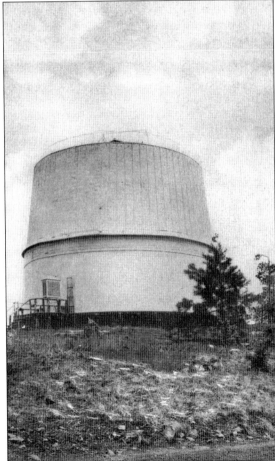

Mars Hill, known earlier as Schulz Mesa, was named in honor of Percival Lowell's studies of the so-called red planet. Many of his observations were made inside this dome.

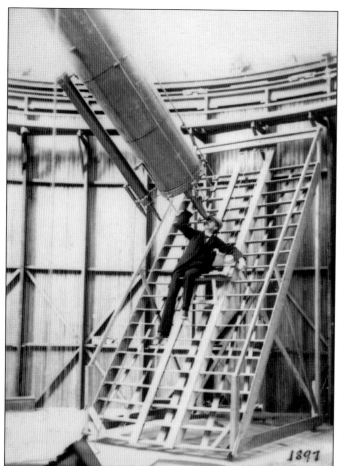

Percival Lowell makes a planetary observation with the 24-inch Clark telescope. The Clark refractor was installed in 1896 in an existing dome, which had been enlarged by Godfrey Sykes. (Courtesy of Lowell Observatory Archives.)

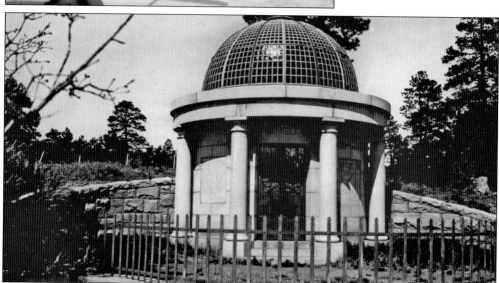

Percival Lowell's tomb was located on the grounds of the observatory he established in 1894. Lowell died at the age of 61 in 1916 after suffering a stroke.

Clyde Tombaugh came to work at the Lowell Observatory in 1929. He was assigned the task of searching for Lowell's predicted ninth planet. In 1930, Tombaugh discovered the planetary body that was christened Pluto, incorporating Percival Lowell's initials. (Courtesy of Lowell Observatory Archives.)

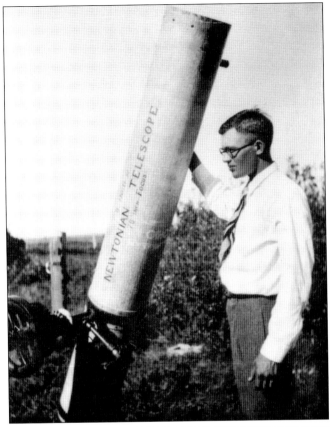

The Ashurst house on West Aspen Avenue is featured in a photograph from 1900. The residence was used as Flagstaff's first weather station by the U.S. Weather Bureau. (Courtesy of Lowell Observatory Archives.)

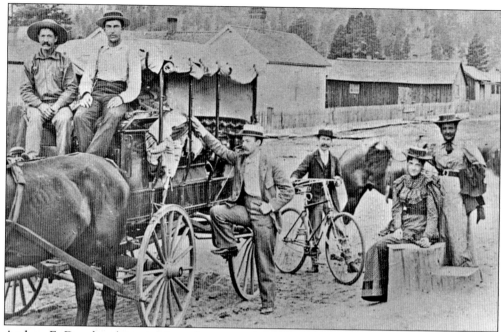

Andrew E. Douglass (stepping into the carriage) was a young Harvard professor who was sent to Flagstaff in 1894 by Percival Lowell to help select a site for a new observatory. Douglass later joined the faculty at the University of Arizona, where he developed the science of tree ring dating (dendrochronology).

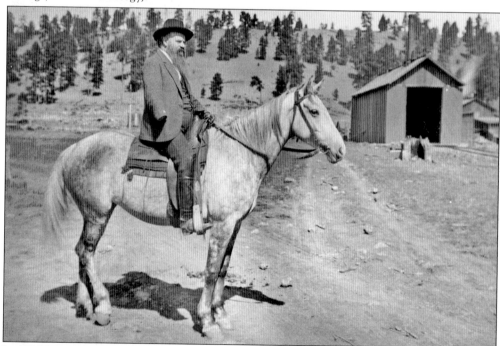

In 1896, Maj. John Wesley Powell was the first to explore the Colorado River through the Grand Canyon. This 1888 photograph shows Major Powell on one of his many visits to Flagstaff, this one as a guest of the Riordans. (Courtesy of Brian and Lois Chambers.)

Pictured at right with their son Ferrell, Harold Colton and Mary-Russell Ferrell Colton visited Flagstaff on their honeymoon in the summer of 1912. Interested in the area's archaeology, biology, and geology, the Coltons relocated to Flagstaff and established the Museum of Northern Arizona in 1927. (Courtesy of Museum of Northern Arizona MS-207-211-3.)

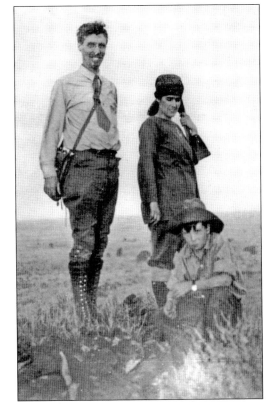

The Museum of Northern Arizona's first exhibits were housed in the Business and Professional Women's Club, which was built in 1923 in the 200 block of West Aspen Avenue. This view shows a group of Native American schoolchildren touring the museum in 1934. (Courtesy of Museum of Northern Arizona C 21-A 1934.)

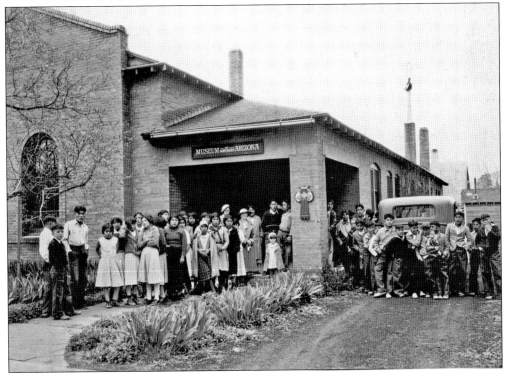

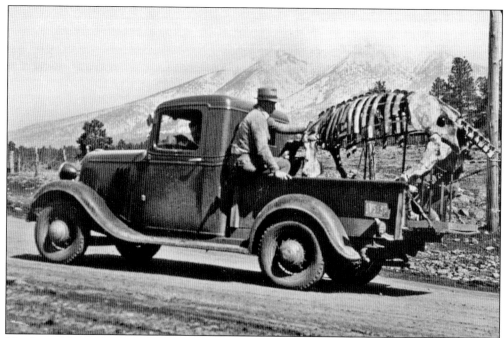

Maj. Lionel F. Brady (driver) was a British-born and Cambridge-educated scientist who became the museum's first curator of paleontology. He excavated and reconstructed an Ice Age sloth skeleton, shown here being transported to the museum for public display. (Courtesy of Museum of Northern Arizona, N-25 89.)

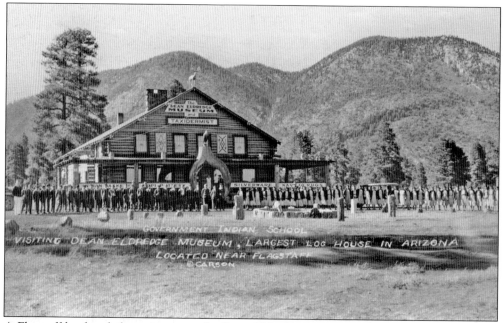

A Flagstaff landmark for many years, the Dean Eldredge Museum was a large log structure on East Route 66 that housed a wildlife museum and taxidermy shop. The structure now houses a nightclub. (Courtesy of AHS Pioneer Museum AHS-PM.0671.0001.)

Ten

Parades and Celebrations

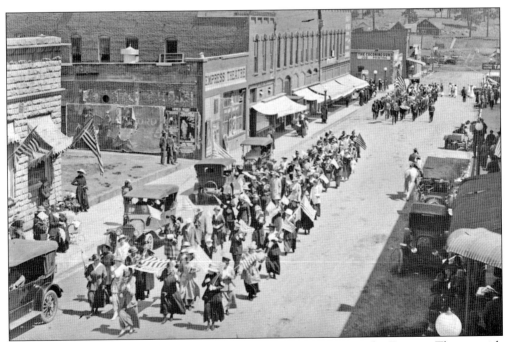

A Fourth of July parade is pictured on Aspen Avenue in 1917. Note the Empress Theatre with movie posters on the outside wall. (Courtesy of AHS-Pioneer Museum AHS-PM 0380.00032.)

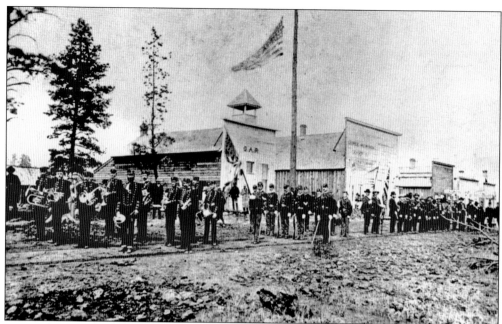

A Memorial Day parade forms in front of the Grand Army of the Republic hall at the corner of Humphreys Street and Railroad Avenue in the 1890s. At the center is Arizona National Guard Company I, commanded by Capt. George Hochderffer (with saber).

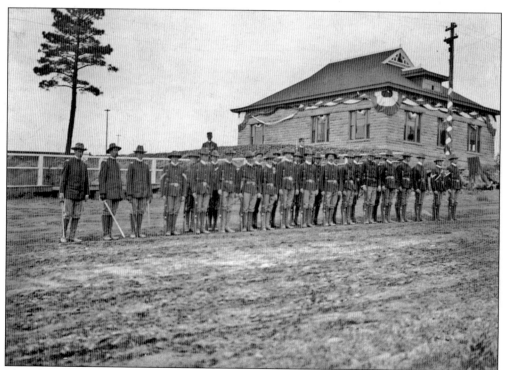

This photograph was taken on the Fourth of July 1902. Soldiers lined up in front of the Arizona Lumber and Timber Company office at Milton. (Courtesy of Brian and Lois Chambers.)

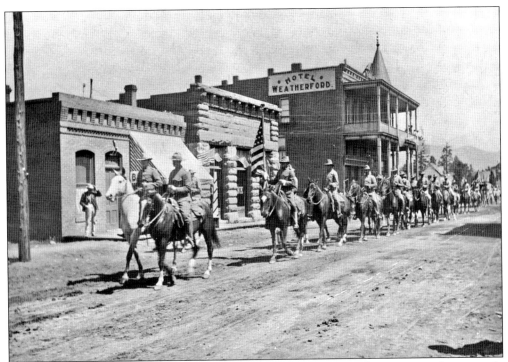

The First Infantry, National Guard of Arizona, participates in a military preparedness parade in 1915. Lt. Col. Fred S. Breen (dark horse) led the parade. Breen was publisher of the *Coconino Sun*. (Courtesy of Arizona Historical Society/Tucson AHS 48605.)

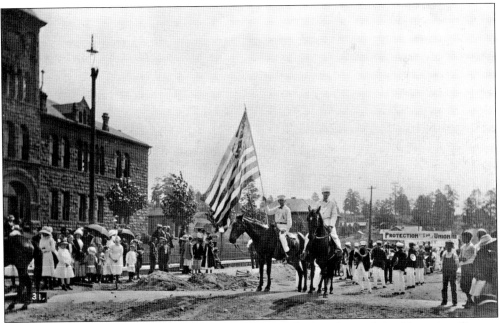

The Independence Day parade in 1896 was photographed in front of the Coconino County Court House. Note the band and the union banner. (Courtesy of Arizona Historical Society/Tucson AHS 48615.)

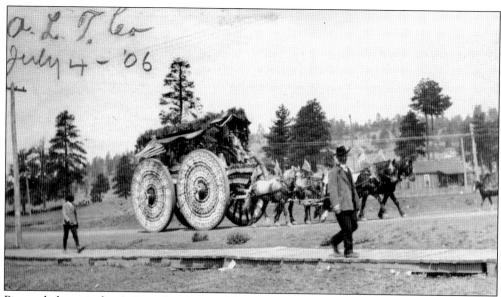

Pictured above is the Arizona Lumber and Timber Company float in the 1906 Fourth of July parade. The float consisted of two sets of large logging wheels joined together and decorated with flags, bunting, and crepe paper.

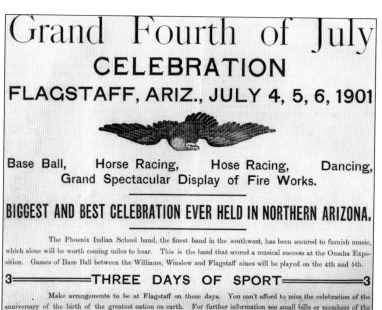

Grand Fourth of July
CELEBRATION
FLAGSTAFF, ARIZ., JULY 4, 5, 6, 1901

Base Ball, Horse Racing, Hose Racing, Dancing,
Grand Spectacular Display of Fire Works.

BIGGEST AND BEST CELEBRATION EVER HELD IN NORTHERN ARIZONA.

The Phoenix Indian School band, the finest band in the southwest, has been secured to furnish music, which alone will be worth coming miles to hear. This is the band that scored a musical success at the Omaha Exposition. Games of Base Ball between the Williams, Winslow and Flagstaff nines will be played on the 4th and 5th.

3————THREE DAYS OF SPORT————3

Make arrangements to be at Flagstaff on these days. You can't afford to miss the celebration of the anniversary of the birth of the greatest nation on earth. For further information see small bills or members of the committees, published in another column of this paper.

This advertisement in the June 22, 1901, edition of the *Coconino Sun* is for the upcoming Fourth of July celebration. The celebration committee was headed by Julius Abineau and included T. E. Pulliam, Dr. D. J. Brannen, M. J. Riordan, George Hoxworth, C. M. Funston, and George Babbitt.

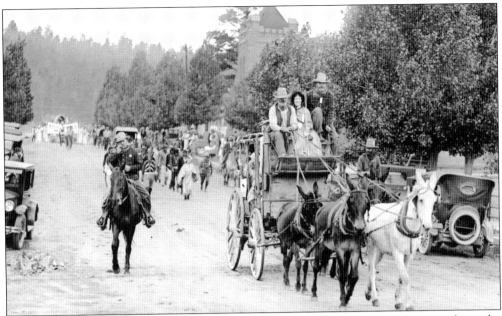

The Days of '49 was a celeration of pioneer life held on the Fourth of July. This view shows the annual parade with wagons, a stagecoach, and a Native American contingent on Aspen Aenue near the Fedearted Church in the early 1920s.

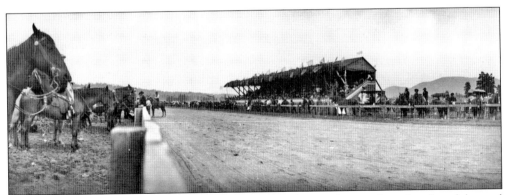

Fourth of July horse racing and fireworks displays took place at the grandstand and track located near what today is Thorpe Park. This is a view of the festivities in the 1890s.

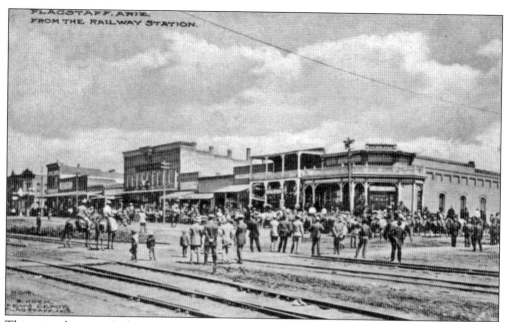

This view shows an Independence Day parade in 1900 at the corner of Railroad Avenue and San Francisco Street. Note the elaborate wood balcony on the G. W. Black Saloon.

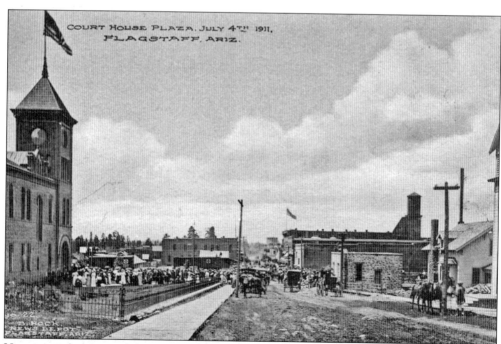

Here is another view of the same 1900 Fourth of July celebration, this time looking south on San Francisco Street from the county courthouse. The Presbyterian church appears at the right margin.

124

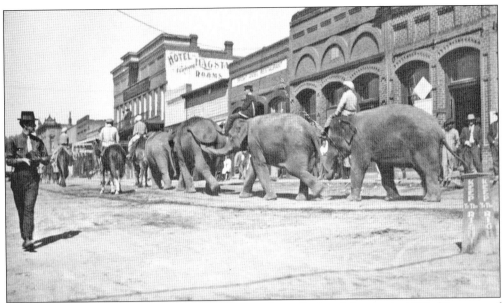

The Barnes Circus comes to town. Elephants parade on Railroad Avenue in 1900. (Courtesy of AHS-Pioneer Museum AHS-PM 0600-00001.)

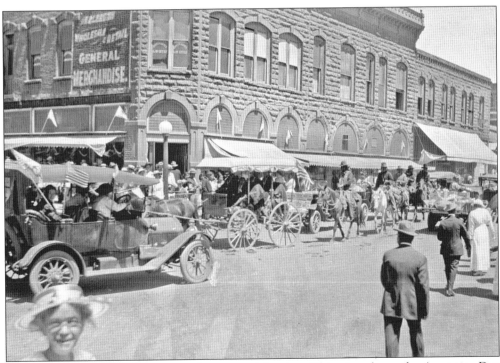

The end of World War I was cause for great celebration. This view shows the Armistice Day parade in downtown Flagstaff on November 11, 1918.

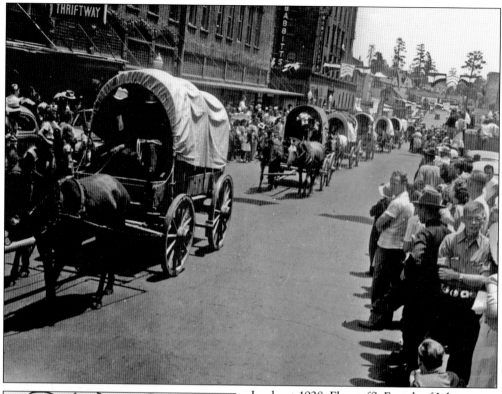

In about 1928, Flagstaff's Fourth of July celebration became the All Indian Pow Wow and Rodeo. Tribes came to town for several days of parades, a rodeo, and evening ceremonial dances.

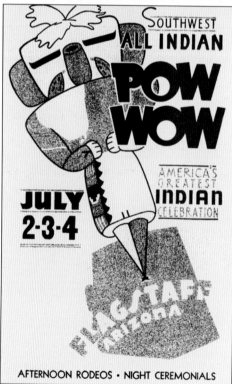

The Pow Wow featured a Native American encampment at City Park and an all-Indian rodeo at the nearby arena. This event attracted tens of thousands of tourists to Flagstaff every year, but it was cancelled in 1980 because of problems with congestion, sanitation, and law enforcement.

BIBLIOGRAPHY

Arizona Illustrated Book Company. *Souvenir of Flagstaff and Coconino County, 1917*. Facsimile Edition. Flagstaff, AZ: Northland Press, 1964.

Cline, Platt. *Mountain Campus: The Story of Northern Arizona University*. Flagstaff, AZ: Northland Press, 1983.

———. *Mountain Town: Flagstaff's First Century*. Flagstaff, AZ: Northland Press, 1994.

———. *They Came to the Mountain: The Story of Flagstaff's Beginnings*. Flagstaff, AZ: Northland Press, 1976.

Flagstaff Symphony Guild. *Flagstaff, 1876–1976: A Random Collection of Antique Photographs and Writings*. Flagstaff, AZ: Nagle Printers, 1976.

"Flagstaff, the Gateway to the Grand Canyon of the Colorado." *Land of Sunshine Magazine*. August, 1897, pp. 1–17. Facsimile reprint. Flagstaff, AZ: Northern Arizona Pioneers' Historical Society, 1975.

Hamilton, Patrick. *The Resources of Arizona*. San Francisco, CA: A. L. Bancroft Company, 1884.

Hochderffer, George. *Flagstaff Whoa! The Autobiography of a Western Pioneer*. Flagstaff, AZ: Museum of Northern Arizona, 1965.

Mangum, Richard K., and Sherry G. Mangum. *Flagstaff Album: Flagstaff's First Fifty Years in Photographs, 1876–1926*. Flagstaff, AZ: Hexagon Press, 1993.

Smith, Dean. *Brothers Five: The Babbitts of Arizona*. Tempe, AZ: Arizona Historical Foundation, 1989.

Tinker, George H. *Northern Arizona and Flagstaff in 1887: The People and Resources*. Glendale, CA: The Arthur H. Clark Company, 1969.

Vabre, Fr. Cipriano. *The Old Santa Fe Trail Across Arizona*. Los Angeles, CA: West Coast Magazine Press, 1912.

Discover Thousands of Local History Books
Featuring Millions of Vintage Images

Arcadia Publishing, the leading local history publisher in the United States, is committed to making history accessible and meaningful through publishing books that celebrate and preserve the heritage of America's people and places.

Find more books like this at
www.arcadiapublishing.com

Search for your hometown history, your old stomping grounds, and even your favorite sports team.